A
CADES COVE
childhood

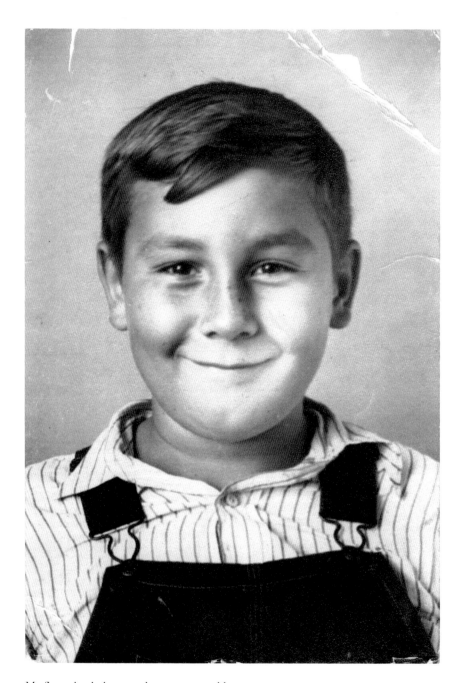

My first school photograph at ten years old.

A
CADES COVE
childhood

Written by Margaret McCaulley
Remembered by J.C. McCaulley

THE
History
PRESS

Published by The History Press
Charleston, SC 29403
www.historypress.net

First published 2008
Second printing 2011
Third printing 2011
Fourth printing 2012

Manufactured in the United States.
ISBN 978.1.59629.556.8

Library of Congress Cataloging-in-Publication Data

McCaulley, J. C., 1929-
A Cades Cove childhood / [transcribed by] Margaret Osborne McCaulley ;
remembered by J.C. McCaulley.
p. cm.
ISBN 978-1-59629-556-8
1. McCaulley, J. C., 1929---Childhood and youth. 2. McCaulley, J. C., 1929---Family.
3. Cades Cove (Tenn.)--Social life and customs--20th century. 4. Cades Cove
(Tenn.)--Biography. 5. Mountain life--Tennessee--Cades Cove--History--20th century.
6. Farm life--Tennessee--Cades Cove--History--20th century. 7. Blount County
(Tenn.)--Social life and customs--20th century. 8. Blount County (Tenn.)--Biography. I.
McCaulley, Margaret Osbo rne. II. Title.
F443.B6M24 2008
976.8'885--dc22
2008027629

CONTENTS

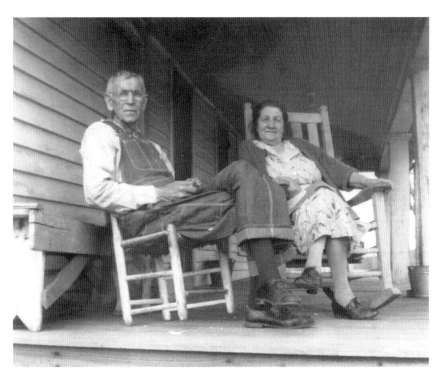

This book is dedicated to the memory of my parents, John and Rutha McCaulley, 1959. *Courtesy of Trish McCaulley Abbott.*

ACKNOWLEDGEMENTS

I would like to thank the people who helped me with this book.
My friend and mentor, Jane Jensen, who encouraged me to begin.

My sister, Mary Upton, whose example inspired me and who kept my nose to the grindstone through one interstate move, two hospital stays and various other crises!

Linda Weaver, who began by advising me on many aspects of putting a book together, and became a friend over many cups of tea and cookies.

Various members of the extended McCaulley clan, who gave me old photos, contributed a few stories, occasionally jogged my husband's memory and were generally interested and enthusiastic.

And of course, that little fellow on the back cover—my beloved husband and best friend.

INTRODUCTION

C ades Cove is a large fertile valley surrounded by mountains, threaded by streams and lying the in easternmost part of Tennessee. Within living memory, it was a viable farming community, inhabited by independent people descending from settlers who first came to a wild and remote area in the 1700s. Now it is a focal point in the most visited national park in the United States. An eleven-mile road circles the valley, and visitors may stop to view log cabins once occupied by the earliest settlers and three churches whose bells once rang to summon them to services on Sunday.

The people of the Cove began to sell their property, most against their will, when the government decided to form the Great Smoky Mountains National Park and started to acquire land in the mid-1920s. Some fought in the courts to retain their homesteads, but it was a losing battle. Some, accepting the small sums they received for their property, left and settled in nearby counties and towns. Many of the older people never recovered from the shock of leaving and, unhappy in their new environments, died shortly thereafter.

The earliest arrivals, and some land speculators, claimed land in the flatter part of the Cove. This land was the most desirable, and soon filled up, being easier to farm. Later arrivals had to locate farther back in the hills, where they cultivated the hillsides and eked out a living as best they could, supplementing their income by cutting timber, trapping and occasionally making whiskey. The population of the Cove rose and fell, numbering about seven hundred people at its peak. Considering the limited amount of tillable land, such numbers began to strain the resources of the area, and by 1900 a steady decline began as people left to seek opportunities elsewhere. Some went to Georgia, particularly when gold was discovered near Dahlonega; others went west to Kansas, Missouri or Arkansas. The ones who remained either had larger farms with more tillable land, or were tough and resourceful enough

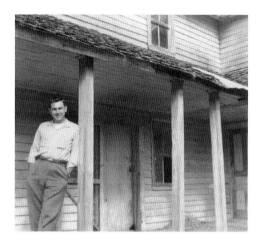

I am standing on the porch of the Witt-Shields house in Cades Cove, 1955. *Courtesy of the author.*

to exploit every possible way to make the cash they needed for taxes and the commodities they could not raise or manufacture.

The log cabins seen today were, in the later stages of the Cove's history, often replaced by substantial houses of planed lumber, which have since been removed by the National Park Service. A particularly attractive example was the Witt-Shields house, which was demolished in the later 1950s. When I lived in the Cove, it was occupied by Alphonse "Fonze" Cable and his family. Mr Cable was a bear hunter and owned excellent bear dogs, so he and my father were friends and I often accompanied my parents there on visits. There were schools and several stores; the community had telephone service as early as the late 1890s; and the Cove's social events were regularly reported in a special column in the *Maryville Times*, including family visits, quilting bees, church events and picnics.

The sacrifice of such a community, however sad, was not in vain. The national park serves an invaluable purpose in preserving vast stretches of unspoiled mountains and forests, providing a haven for wildlife, trails for hiking and horseback riding, fishing, camping and a retreat from our all-too-hectic lives.

Few people who were actually born and remember living in the Cove now remain, but their children and grandchildren are proud of their heritage and cherish what remains of those times.

When my wife came from England to marry me, she was warmly welcomed into my "Cove family." On many Sunday afternoons we sat and talked under the maple trees at my parents' farm. After years away from their mountain home, they still told Cove stories many times over until, she said, they almost seemed part of her own history. Here are a few of those stories and recollections of my childhood.

MY FAMILY

I am J.C. McCaulley, the son of John Thomas and Rutha Angeline Myers McCaulley. I was born in Cades Cove in 1929, the last of nine children. The family lived there until 1936, when we left our home to settle on White's Mill Road at Hubbard, near Maryville. We were among the last residents to leave the Cove, my parents having sold our seventy-five acres to the Park Service.

My father was the last son of James, the first McCaulley to settle in Cades Cove. Little is known about James's people, but at the beginning of the Civil War, we know he was living in the small settlement of Walland, Tennessee, with his wife Unity Elizabeth Caldwell. They had one child and were expecting another. Most of Blount County was pro-Union and so was James—at the age of thirty, he went to enlist in the Union army. Tennessee earned its nickname (the Volunteer State) because it sent more men to the war—to both sides—than any other state. With several friends, James walked to Kentucky to enlist in the Third Tennessee Cavalry, first serving as a cook and then as a blacksmith, which was his trade. Surviving the war safe and whole, he was discharged at Pulaski, Tennessee, in 1865 and made his way home to Walland to be reunited with his wife and children.

With his growing family, James remained in Walland for some years, presumably following his trade as a blacksmith. In 1879, he made the decision to move to Cades Cove. His arrival was announced in the Cades Cove column of the *Maryville Times*, which stated that he was an extremely welcome addition to the community as they had no blacksmith—a valuable man in any farming area. Before he built his smithy, a broken plow or harrow might mean a long trip to get it mended, perhaps as far as Maryville.

Owning no property as yet, he rented a place for several years, and it was during this period that his last child, my father, was born in the year 1880, in the Tipton-Oliver cabin that still stands beside the Loop Road.

James McCaulley
1832 – 1906
m.
Unity Elizabeth McCaulley
1841 – 1909

John Case Myers
1854 - 1934
m.
Mary Ann Gregory
1858 - 1935

John Thomas McCaulley ———— m. ———— Rutha Angeline Myers
1880 – 1961 1884 - 1966

May	Millard	Mayme Ann	Vicie Louisa	Icyle	John Earl
1903-	1905-	1907-	1909-	1911-	1913-
1906	1976	2001	1977	1992	1999

William Freeland
1917-
1996

Anna Lee
1919-
1990

J.C.
1929-

Above: This small chart shows my immediate family. I am the only surviving grandchild of James McCaulley.

Left: My grandfather, James McCaulley, in his Civil War uniform.

My Family

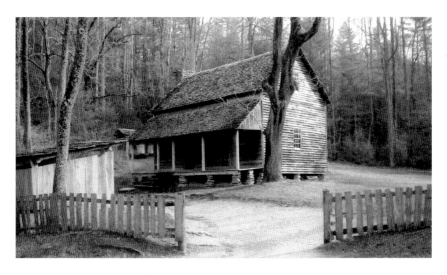

My father's birthplace, the Tipton-Oliver cabin. It still stands beside the Loop Road that circles Cades Cove, 2007. *Courtesy of J.C. McCaulley.*

At that time, several other buildings were located beside and around the house; James must have used one of them as a smithy but we have no way of knowing which one.

The family remained there for several years. My father would sometimes tell of the day his older brother Jim left home. Dad was four or five years old and swung on the barn gate as he watched Jim walk away across the fields toward the storied West. Jim was to come home from Kansas just once. Dad remembers the visit and how they would sit around the fire hearing tales of Jim's life as a cowboy, roping and rounding up the cattle.

There were eight children in James's family. Most of them remained in Blount County and in touch with one another. Recently, my wife and I drove through a neighborhood I knew well as a child. It didn't look so familiar now, the rolling hills being divided up into estates with large, beautiful homes in place of the small farms I used to know. Suddenly, a turn in the road jogged my memory. There was an old lot with large trees and an ancient cistern, though no house stood there any more. This was the homeplace of my uncle Bill, one of Dad's older brothers. He had several hillside acres there and some bottom land down along Ellejoy Creek. I remembered Dad taking me there often to visit him.

Uncle Bill always grew a small patch of tobacco. He liked to chew it, and preferred to grow his own. He raised the tobacco and hung it in the barn to cure. At just the right stage, he added his own special touch,

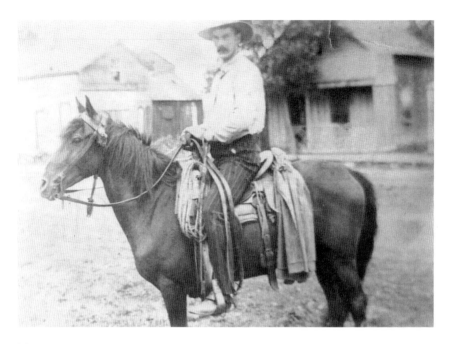

My uncle Jim, working as a cowboy in Kansas.

combining the leaf with licorice and perhaps some molasses. Then he separated the leaves into bundles. Some were shaped into plugs, some were twisted into long cones, but all were put into a press until they cured and were very hard. This took six months or more. He kept a good supply on hand and Dad usually took home a few.

On his arrival in the Cove, James continued his trade as a blacksmith but later was able to buy land for farming. He built a log cabin and shops where, for twenty-five years, he practiced his trades of carpentry and working in iron, making and mending any kind of implement his neighbors might need. He had many skills—it is believed that he built the chimney at the Henry Whitehead cabin on Forge Creek Road, where many visitors today stop and enjoy a picnic lunch on the porch.

When the smithy was established, people brought him equipment to be repaired, and often horses to be shod. One day a young man arrived with a horse needing a shoe. James began work, having to ask the fellow several times to stand back from the forge as he hammered on the red-hot iron. The youth would stroll back and forth for a while in his high boots, sloppily laced so that the tops stood open, but would always come back and stand too close

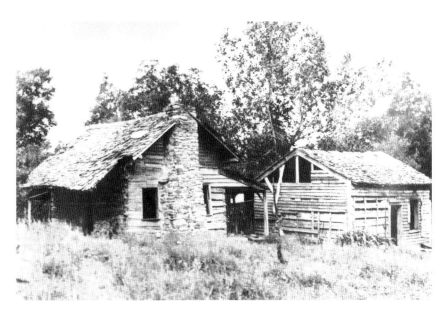

The cabin and shop of my grandfather, James McCaulley. *Courtesy of the National Park Service Archives.*

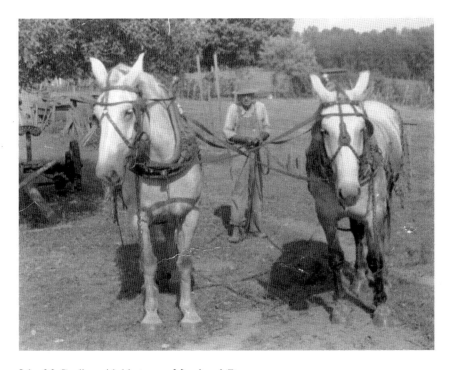

John McCaulley with his team—Maud and Queen.

to the fire. James gave up asking him to move, even when the man propped his foot up right beside the anvil. Then as the shoe began to take shape, a piece of glowing metal flew from the hammer and down into the boot.

My father was probably present helping James when this happened; when he told the story, he always said that the dusty dirt floor of the smithy was so churned up by the young man's efforts to get outside that it took five minutes to find where he went. No doubt he ran as fast as possible to the cold stream that ran beside the smithy.

I believe James had a closer relationship with my father than with his older sons. Together they made many a hunting and camping trip, James teaching Dad all he knew about how to survive, hunt and travel in the mountains. Dad was the son who helped James as he made coffins for the community, learning a skill he was to use many times in later years. In some ways, this resembles my own relationship with Dad—being the youngest son, I also stayed at home longer, working on the farm. My help was necessary as he aged, particularly when the tractor needed maintenance and repair. Although he eventually owned a John Deere, Dad was never quite as comfortable with a tractor as with horses!

Dad was pretty safe when working a tractor in a large field, but parking in a restricted space could be a problem. Once I was working in our large barn at Hubbard when I heard him approaching on the tractor, intending to park it in the adjoining stall. Forgetting that the tractor differed from a car in that it had a hand clutch, he was desperately pumping the wheel brakes and yelling "Whoa, whoa!" to no avail. The next thing I heard was a loud crash as the tractor went through the back wall of the barn. Luckily the only damage was to Dad's temper and a number of broken boards.

MY PARENTS' EARLY DAYS

My father married Rutha Angeline Myers in 1902 and in 1903 they had a baby girl named May. They lived close to her grandparents, James and Unity. When May became ill with diphtheria, her devoted grandfather spent most of his days helping to care for her. Diphtheria epidemics claimed many children in those days, and sadly, May died in September 1906. She was three years old. James never recovered from his grief and died a few months later. Their gravestones can be seen side by side in the Methodist cemetery.

At that time, my parents lived in a small frame house on James's property, but when James died, Dad needed land of his own. Like many men of that time, he did not consult his wife about financial decisions, and so bought seventy-five acres without telling Mother, who burst into horrified tears upon hearing that he had spent the tremendous sum of one hundred dollars, their entire savings, and still owed fifty dollars. "We'll never in the world pay all that money! We'll starve to death!" she said. However, the deal was done. John and Rutha, with two children, moved to the farm he bought from J.M. Ledbetter.

Although the date of purchase was October 1908, the warranty deed was not recorded until May 1914. Since the recording fee was fifteen dollars, it's likely that there was no money to spare for that purpose. Dad first had to scrape up two more annual payments of twenty-five dollars before the farm was paid for.

That remaining fifty dollars may have been hard to come by, but my father could turn his hand to many trades and make a little money from all of them. He was first and foremost a farmer, but he was also a great hunter, by which he put meat on our table. He kept bees and sold excellent honey, which people came from some distance to buy. He cruised timber for several logging companies and guided hunting parties. During the

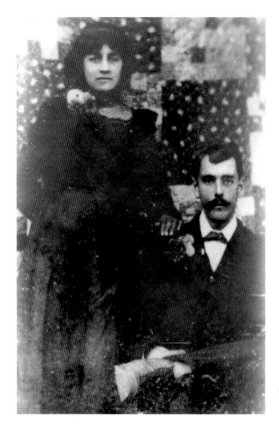

John Thomas McCaulley and Rutha Angeline Myers on their wedding day, 1902.

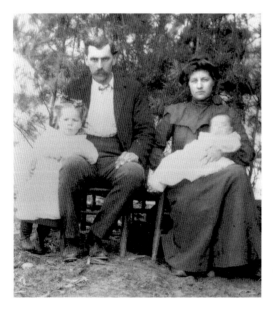

John and Rutha McCaulley with their daughter May and baby son Millard.

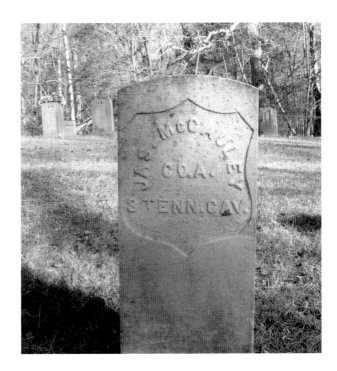

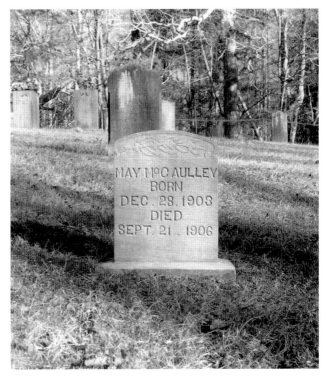

This page:
Gravestones of
James McCaulley
and May
McCaulley, 2006.
*Courtesy of Margaret
Osborne McCaulley.*

Warranty deed for the Ledbetter property.

hard times of the late twenties and thirties, he often had to leave the Cove to find employment, leaving my mother to manage the family and farm alone. One of the men he guided on hunting parties was an executive at the Aluminium Company of America at Alcoa who, knowing how hard Dad worked to make every dollar, got him a job there. Dad gave it a try, but didn't stay long. Raccoon coats were popular then, and he declared

The badge my father wore when
working at the Aluminium Company.

he "could make as much money trapping 'coons and be home by dinner time." He appreciated the opportunity but left for the freedom of his beloved mountains. Dad never did like being "hemmed up" in four walls.

It was possible to ship the raccoon hides out, but Dad preferred to sell his to Tom and Jerry Hearon of Happy Valley. Tom and Jerry were fellow turkey hunters and there was always some friendly competition going on, so when Dad had accumulated enough hides and the brothers came to collect them, they would swap hunting stories when the business transaction was completed. A prime coonskin could bring up to nine dollars, which would buy a lot of groceries during the Great Depression. Mink or muskrat brought more, a mink as much as twenty-five dollars, but they were rare.

When I was older, living at Hubbard, I sold a few hides myself, but mine were 'possum skins, which sold for very little—fifty cents each, as I recall. However, I enjoyed the hunt so much that I would go out eight nights a week if I could!

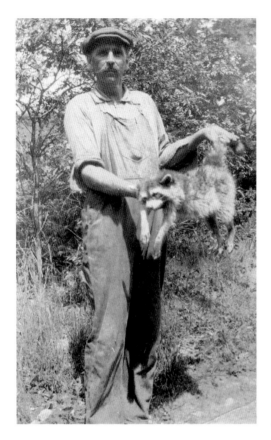

A nine-dollar hide—and dinner!

Though they sold for so little, 'possum skins were more trouble to prepare. Unlike any other hide, they had to be removed in one piece, carefully stripping the skin from the carcass and turning it inside out in the process. It was then stretched on a board, fur inward, and every shred of flesh and fat scraped away. They were then hung to dry and sold still inside out. Serious 'possum hunters kept boards, shaped roughly like a long triangle with rounded corners, in various sizes.

There is an old joke about a man who owned a 'possum-hunting dog so clever that he only had to be shown a board and he would go out and bring back a 'possum to fit it. One hot day the dog was lying in the yard when his owner's wife brought out her ironing to the porch, where it was cool. As she set up her ironing board, the dog raised his head and watched with interest. In a few minutes, he ran off into the woods.

The dog has never returned—he is still searching for the monster 'possum whose skin will fit that ironing board.

OUR HOME IN THE COVE

We lived on a hillside farm at the west end of the Cove. It lay just across the hill from the parking lot near the entrance to Parson's Branch Road. The hollow that once led to the farm is now blocked by large boulders, placed there by the Park Service. The road ran between a high bank on the right and Post Branch on the left, overhung with large trees and lined with rhododendron, which we called "mountain laurel." Reaching our home, the hollow widened out into a clearing, with the stream running through the middle, joined by a small branch from the spring where we kept our milk and butter. Most of the property consisted of steep pastureland, though we did have an apple orchard, a large garden patch and cornfields.

Because our farmland was mostly steep, the cornfields were small, squeezed in wherever the land was tillable. Sometimes Dad would rent land down in the more level part of the Cove in order to grow a bigger corn crop, the mainstay of every Cove farmer. Those with suitable land also grew wheat, not only for the grain but because the straw was used for stuffing mattresses—"straw ticks." These would be filled with fresh straw each year at threshing time. People who had neither straw nor feathers stuffed their ticks with corn shucks, but as I remember we had mostly feather beds, so my mother probably bought the feathers from those who kept flocks of geese. However, since we had a large family, she couldn't afford featherbeds for everyone. I remember that we still had beds with straw ticks on them when we moved to Hubbard.

For seven years, my parents lived in the tiny cabin that was already on the Ledbetter property. The boys slept in the loft, where the spaces between the logs let in the cold wind. My brother Millard told me that he often woke on winter mornings with snow on the bedcovers.

Times in the log house could be very lean. Despite Dad's best efforts, money was scarce and occasionally there wasn't much to eat. One such time

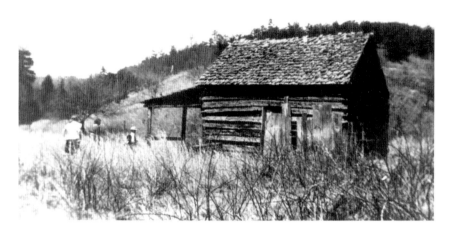

The original Ledbetter log cabin, 1943. *Courtesy of Dulcie Abbott McCaulley.*

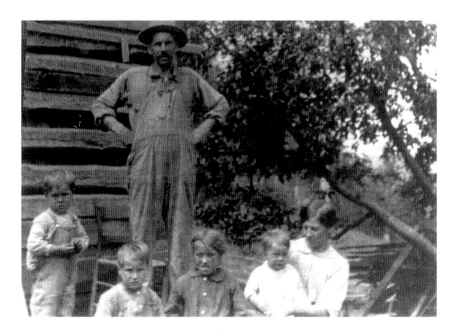

My parents, with four of their children, still living in the tiny cabin.

came, and it was worse than it had ever been before. There was nothing in the cabin to feed the children, and no money to buy food. Dad knew of a smokehouse nearby in which plenty of hams and bacon were stored. It belonged to J.W. Post, who had sold his property and moved out, only coming back occasionally to spend a few days in a small vacation cabin.

Dad went to the smokehouse, broke the lock and took a ham. Back at his own cabin, he hid the meat and said nothing to anyone. All night he agonized over whether he could bring himself to keep the meat, but in the morning he took it back, hung it in the smokehouse and repaired the lock.

Within a day or so, a group of men arrived to engage his services as a guide, paying him five dollars in advance. With this money he was able to buy a supply of food and no doubt felt that God had rewarded him for doing the right thing.

Not even my mother ever knew about this incident. Dad only related it to my brother Freeland shortly before he died.

A NEW HOME

The tiny Ledbetter cabin must have been a crowded and primitive dwelling for two adults and eventually, seven children, but in 1921 Dad built a bigger house of planed lumber with a front porch and a basement. I was born in this house and lived there until I was eight years old. My brother Millard was about sixteen when the house was built so he and sister Mayme (always a hard worker even as a young girl) split shingles for the roof and helped with other construction chores.

At last there was room for everyone. My parents had a bed in the living room, which was the usual practice. Freeland and John Earl shared a bedroom and there was another in the basement for the girls. They had to go outside the house and enter it from the lower porch. The children still at home when I was born were Johnny, Freeland, Icyle and Anna Lee. When Icyle got married, Anna Lee had a room to herself, of which she was very proud and loved to take visiting cousins to play there. I, the pesky little brother, was forbidden to enter but I'm sure I "snuck in" once in a while!

For all the years that we lived in the new house, there were a few details that were never quite finished. The planks on the sides of the house remained untrimmed, and the porch lacked some flooring—we just learned to walk around the holes! As it was situated on a steep hill, water for washing and cooking had to be carried in buckets from the spring below—running water or an indoor bathroom would have been a luxury beyond the dreams of this mountain family.

We had regular mail delivery quite close by. John Oliver was our mailman. For years he carried the mail on horseback but probably by the time I was two or three years old he had upgraded to his Model B Ford. Our mailbox was no. 17. Almost every day, my sister Icyle would take me down to see if we had any letters—Icyle was extremely shy and she

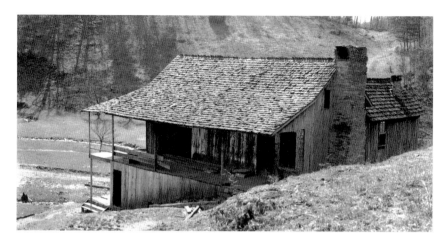

The house Dad built in 1921.

made it a game to hide in the bushes until our mail was in the box and Mr. Oliver had gone on his way.

We never had a telephone. A telephone line into the Cove had been in existence for many years but few houses actually had a phone. Most of those were at the "upper end," so in case of emergency a runner or rider would go to one of them to summon help from outside.

After the new house was built up on the hillside, Maw continued to do the "warsh" down in the flatter area near the old house. Carrying water up the hill to the new house for cooking and bathing was hard enough without doing laundry there. She would build a fire near the spring and heat water in an iron kettle, boiling the overalls and shirts and after "renching" them in a tub of fresh water, she would hang them on a line.

The old house was then being used for storage of large tools, lumber and Maw's washtubs. Barrels of pickled corn and beans were kept there, and Dad also built a lean-to on one side to shelter his car.

We also had another barn, big enough to drive a wagon through and with stalls on each side for horses and our milk cow. The barn was located close to the "branch," so Dad could easily back his wagon down into the water after a dry spell or long use. This was done to swell the wooden wheels and make the metal rims fit tighter.

A large tomcat lived in the barn, a great mouser but so wild he would not allow anyone to touch him. Dad and a couple of my brothers managed to catch him one day, muffled him in sacks and castrated him. It didn't make him any tamer but he was a wonderful barn cat and we took him with us when we moved to Hubbard.

Groups of people from Maryville or Knoxville came often to camp near our house in the summer, so with these visitors and relatives who lived in the Cove we had fairly frequent company even in our rather isolated location. Mase Bartlett was a friend who came every year, and knowing small boys, he would bring me a pocket knife. Knowing boys very well, he brought one every year because the one from the year before had always been lost!

Jack Gamble and his family also camped each year in a hemlock grove "up the holler." The thick layer of fallen needles under the big trees made a comfortable bed and it was a popular camping place. It was also close enough for me to trot up there and see what treats visitors had brought all the way from town—especially bananas. I had and still have a great fondness for bananas and was always hoping that visitors would have one or two for me.

In 1929, when he was forty-eight years old and I was a small baby, Dad bought the first car he ever owned. He had somehow scrimped and saved up enough money for a Chevrolet touring car. It was dark green, and had a canvas top and isinglass curtains that could be attached when it was cold or rainy. To make this important purchase, he took his thirteen-year-old son John Earl to Maryville Motors, then situated at an intersection nicknamed "Calamity Corners," took from his pocket a large wad of greenbacks and proudly paid $525 in cash. Unfortunately, he shortly had an accident with his new purchase. Returning from a trip to Maryville with my mother and me, two months old, he collided with a logging truck. This happened near the house of his friend Jack Gamble, and they took us in for the night. The car wasn't badly damaged and no one was hurt, although Maw said she combed glass from my hair for several days.

Maryville Motors is still in business seventy-eight years later, though it has moved out of town and is now known as West Chevrolet.

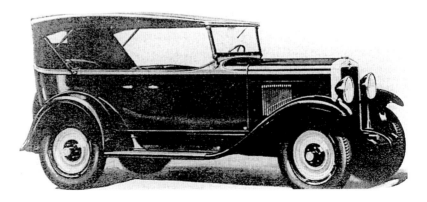

Dad's 1929 Chevrolet touring car.

Dad's car became quite well-known, because he added his own special touch. He lined the insides of the doors with the hide from a bear he had killed—only John McCaulley would do that! He was working at one of the Tennessee Valley Authority (TVA) hydroelectric dams at the time and having a car enabled him to come home on weekends without making the long hike through the mountains. As Vic Weals put it in his book *Legends of Cades Cove and the Smokies Beyond*: "The man who leaned on the wind of the high Smokies all his life enjoys his new car"—a great description. The car was eventually sold to a neighbor, who remodeled it, putting a small truck bed on the rear. He didn't remove the bearskin though!

Apart from our occasional trips to Maryville, we made very few expeditions outside the Cove, even after we had a car. However, when I was about four years old, Dad decided to visit his brother Mose, who had moved to Paragould, Arkansas, years ago. Traveling were Dad and Mother, a young friend named Dane Gregory and me. Dane had been recruited to do the driving. Dad didn't feel confident about undertaking such a long trip.

The car was loaded with provisions and quilts. We probably bought some food along the way and washed up at service stations, but there would have been no motels in those days, even if Dad had been prepared to pay for rooms. The trip must have taken three or four days. At night, we pulled off the road and found a suitable place to camp. While Mother and I made beds in the car, Dane and Dad cut grass and piled it up to cushion the hard ground.

Uncle Mose's house was about ten miles west of the St. Francis River, in the flatland of the Mississippi Delta. As we arrived, we found that there had been so much rain that year that the river had overflowed its banks and was almost up to the doorstep. Good thing that the house was built on stilts, which seemed very strange to me.

I saw Uncle Mose once more after that trip. He came to visit us at Hubbard when I was twelve or thirteen. He wanted to hike to the Gum Bottoms, an area near the Cove that held memories for him and he wanted to see it again. Dad and I led him through the brushy woods. Uncle Mose was surprised to see the cleared area he remembered now grown up in trees. He also must have forgotten a few hazards of traveling in the mountains, because after I cautioned him about stepping in some bear scat, I noticed that he stayed very close to us. He stayed even closer when I jumped over a fallen log and narrowly missed a copperhead lying behind it. Dad had his walking stick and killed it.

In 1936, when Dad had received payment in the amount of $3,000 from the Park Service for the farm and we were moving from the Cove, he needed a full-size truck. He bought a bright red "pickup" to move our furniture and

other belongings to Hubbard, where we now had a larger house and a farm of 107 acres. It was better land, tillable, on a paved road and closer to town and to a school for me. It had a peach orchard, fields for growing wheat and oats and enough pasture land to support a small beef herd. But Dad yearned for the Cove for the rest of his life. When his chores were done and he had a little time, he would sit on the front porch and watch the clouds roll over Chilhowee Mountain, reminiscing about the good old days. "Let's talk about them old Smoky Mountains," he would say.

One note about the pretty red truck—it probably didn't stay pretty for long, being employed in every kind of rough farm-hauling job. When it got older, scratched and bent, my brother Freeland and I painted it black. It probably wasn't the smoothest paint job ever; we did it with the only tool we had—an insect sprayer.

The few cows we could keep on the hillside farm in the Cove had to be driven on foot to our new home at Hubbard. This job went to Freeland and cousins Charles and Arthur Wright. Freeland was about twenty years old, Charles and Arthur a little older. They went by way of the Cooper Road, a trail that branches off from the Loop Road and goes over Chilhowee Mountain. It was an old wagon road, already out of use by 1935 and probably always very rough, but they could go that way without encountering traffic. It must have been a very long day's walk, about twenty-five miles, with the "lead cow" on a rope and two or three others following behind. Furniture had not been moved into the Hubbard house yet, so they slept on the floor that night. They had brought a dog with them, but in the morning, when starting back to the Cove, he was nowhere to be found. The boys left without him, but when they arrived home the dog was already there. The Cove was still home to him, but he soon had to make the adjustment, like the rest of us.

The great adjustment for me was losing my freedom and going to school. I was eight, and bigger and older than most of the children in first grade, which was an embarrassment. I had a long walk to school, and went a little earlier than most other children because I soon got the job of starting the wood stoves every morning. I split kindling, carried in a supply of coal and got the fires lit so that the rooms would be warm before the students arrived. Each teacher paid me fifty cents per week.

There was a hazard to be avoided on the way to school. Mr. Wade Wells's goose liked to nest in the honeysuckle vines along the road and didn't like anyone passing too close by. She chased me on many occasions, and as I ran I looked back wistfully on my days of running barefoot and carefree in the Cove woods.

ANIMALS TAME AND WILD

Down the hill in front of the Cove house was a long shed that sheltered the beehives. Bees seem to like some people and not others—they often stung me, but Dad would just button up his shirt and carry a smoker when going to collect the honey. I remember my brother Freeland being allowed to play with the smoker. He would direct the smoke through the stones of the little rock wall behind the hives to see where it came out. I thought this was great fun, until one day three copperheads emerged along with the smoke! This was hardly an occasion for panic, as encounters with snakes were not rare around our homestead. Freeland once came upon a six-foot rattlesnake when going out to bring in the milk cow. He yelled back to the house for someone to bring him the shotgun, and he killed it.

Dad had a closer encounter with a rattlesnake while walking back home with a companion from Maryville. They stopped at an abandoned log house as it got dark—"we always laid down wherever night come on us," as he put it. It was a cold night, and when he awoke in the morning, he became aware that *something* was sharing the warmth of his bed, and that something was a snake that had "denned up" for the winter in the old house. It could have been harmless, but taking no chances he leapt out of bed as fast as he could and found that it was indeed a rattler, fortunately sluggish and slow from the cold.

We had some mules and a small burro that were used to carry supplies when guiding hunting and camping parties into the mountains. Once, Dad was leading his little pack train up a trail loaded with equipment, and accompanied by two ladies who were not used to such wild country. One of them asked him if there were snakes about. "Yes," Dad replied, "but don't worry about them. If you get bitten just swallow two grasshoppers backwards and you'll be fine." He delivered this advice with his usual straight face and the ladies asked no more questions.

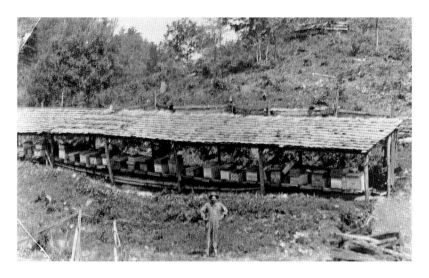

Dad with his beehives. Honey provided income and was good on our morning biscuits!

Dad had another precaution against rattlesnake bites that he sometimes described to credulous listeners. "We usually wear sheepskin leggings," he said, "with the wool on the outside. When the snakes strike, their fangs get tangled up in the wool and we jest reach down and cut their heads off with our pocketknives. Then when we stop to rest we pull off the heads and throw 'em all away."

It's obvious from these stories that Dad didn't share the fear of snakes that so many have, even people who have grown up where they are common. I have many friends who will never venture off a paved road in the mountains "when snakes are out." They would rather hike on a zero-degree day than risk meeting one, even if it is perfectly harmless. Superstitions and tales of what snakes will do abound and most are completely unbelievable. How many times have I heard people relate their sightings of hoop snakes with tails tucked in their mouths, rolling in pursuit of whoever is running from them. Or the milk snakes that creep into the barn and drink milk right from the cow. Everyone "knows" that a snake, even when chopped to shreds, doesn't die until the sun sets—and so on. Once in a while there is someone sensible enough to let a black snake live around the barn or corncrib, knowing that it will rid the place of rats and mice. As I ran out barefoot to play in the morning, Maw would say, "Watch out for snakes!" and I did, though not with any great apprehension. It was just second nature to look on the other side of a log before jumping over, and to be careful about what I picked up.

Dad always had a wry sense of humor. One day he went to visit a neighbor, and seeing the man plowing at the far end of the field, he quickly climbed into the branches of a tree where he would be well hidden. As the farmer passed beneath the tree on his next round, Dad called out in his deepest bass voice "I am God! Calling you to preach!" The man stopped dead, but seeing and hearing nothing more, continued his work. Next time he came around, Dad said, louder, "I AM GOD! CALLING YOU TO PREACH!" The man dropped the reins and ran full speed to the house, calling out to his wife, "God is calling me to preach and I better start NOW!" Dad climbed down and chuckled as he went home.

On his many wanderings through the mountains, hunting or exploring, Dad observed many wild creatures. On one of these journeys, he stopped to sit and rest on an outcrop that had a great view of the valley in the distance. Soon he saw an eagle gliding to and fro below where he sat. It appeared to be playing—as it flew, it carried a stick; reaching a good height, it would drop the stick and in a few moments dive to catch it in its talons. The eagle did this many times until it tired of the game and flew away.

In earlier times, settlers in the Cove had many encounters with bears. They were not considered dangerous unless you met a sow with cubs, but they soon learned there was food to be found around the homesteads, and would sometimes come to raid beehives or hogpens, usually at night. After a few losses of honey or meat, one or two men would take their dogs to hunt down the animals or at least drive them higher into the mountains—"we put them on the back streets," Dad said.

The introduction mentions that Cove people would occasionally move on to the Western states, perhaps to join relatives or because they felt there would be better farming land available there. One animal story concerns such a couple who set out for Missouri about the turn of the century, obtaining a team of oxen from "Uncle" Noah Burchfield to pull the wagon loaded with their baggage. They probably left in summer or early fall, intending to get established on a new place before putting out a crop in the spring. Some months after their departure, Uncle Noah got a despairing letter from them. Their oxen had disappeared, they said— stolen or strayed—and they had no money to buy more and didn't know how they were to make a living without them.

One morning late in the following spring, Uncle Noah went to the barn to feed his stock. At the gate stood the team of oxen, waiting to be let in. They had walked home from Missouri. Obviously this could only happen at a time when there were no four-lane highways with non-stop traffic, and land was not everywhere fenced in—still, it was an incredible journey. I have often

wondered how and where they managed to cross the Mississippi River, and why no sharp-eyed farmer noticed that they were wandering loose and put them in his barn. A fine team of oxen would have been a very fortunate find.

Uncle Noah took them up to the high mountain pastures for the summer along with his own cattle, and, when they were fat and healthy, sold them and sent the couple the money.

Dad heard about this from his friend several times and, as he said that Uncle Noah was "straight as a stick" and would never make up such a story, it had to be true.

Uncle Noah seemed to have a softer heart for animals than farmers usually do—farming is a hard life and when a beast outlives its usefulness, it can no longer be given food and a place in the field. Noah kept an old mule until it neared thirty years old, allowing it a restful retirement in his pasture. Bill Lea relates in his book *Cades Cove: Window to a Secret World* that a neighbor asked why he still kept the animal. "He's served me well and I keep him for the good he's done" was the reply. Uncle Noah was eighty-one years old himself at the time and no doubt felt some kinship with his "good and faithful servant."

Even wild creatures could get a helping hand from Noah Burchfield. Feeding his geese one winter day, he noticed a wild goose among them. With shelter and plenty to eat, the goose remained all winter, but on a cold spring morning, as Noah came to scatter corn, the goose walked out of the barn. Looking toward the rising sun, it seemed restless, and in a few moments, flew away. No sound or movement could be detected by human senses, but the wild goose knew its own kind was near, and it went to join them.

Uncle Noah's house still stood empty beside the Loop Road in the 1950s. Knowing that it was soon to be torn down, I climbed into the attic one day to see what might be left there. Carefully laid away, I found a pair of high-laced boots, and remembered hearing that a young girl in the family had long ago died in her teens. I took the boots home, and for the next fifty years they went with me—to Florida, to Georgia and finally home to Tennessee, where they are now to be seen in the museum of the Cades Cove Preservation Association.

FAMILY AND FRIENDS

My brother Millard and sister Mayme were each married and had children of their own by the time I was born. My mother was then forty-five, and no doubt I was something of a surprise—the next child up from me, Anna Lee, was ten years old. In 1929, there was no resident doctor in the Cove. Dr. Ishom was sent for from Townsend, but did not arrive until three days later. A local midwife must have assisted at my birth but I don't know who that might have been.

Since my mother had given away all the baby clothes she had, she received quite a few gifts of clothing for me, recorded in my baby book. The list includes several dresses, appropriate wear for boy babies in those days, and one item called "supporters" from Mayme. I can only guess that they were suspenders for holding up my long stockings, visible in my baby photograph. Just the thing for the nattily dressed Cades Cove baby of 1929.

Mayme's son Arnold was born eleven months before me, and the two of us grew up more like brothers than uncle and nephew. When Mayme came to visit, she would bring Arnold to play with me, and sometimes he would be allowed to stay the night. He insisted on sleeping on a sheepskin on the floor beside my bed. He and I remained close until his death in 2003. Because of the age difference between me and the children still at home, it was a rare treat to have a playmate of my own age. I spent most of my hours playing alone, fishing for minnows in the stream that ran down the hollow and climbing on the two white rocks beside the creek that seemed so huge to me then. To this day, I tend to be self-reliant and quite content to spend time alone.

On one of my solitary expeditions, I had my first experience with alcohol. I was about six at the time. Playing on the big white rocks down along the creek, I had discovered a crevice in the rock, and in it was a keg full of some sweet-tasting liquid, with a handy straw in it. A very

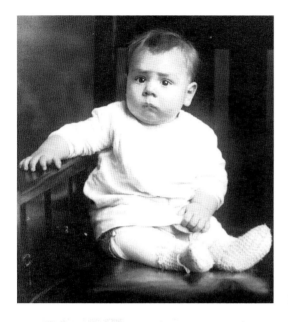

My first baby picture.

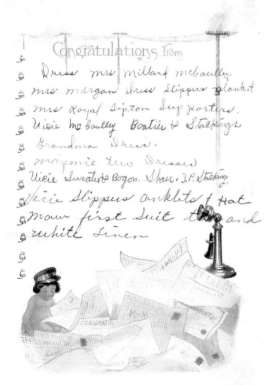

Gifts at my mother's baby shower—she was forty-five years old.

refreshing drink for a hot day, and I enjoyed quite a lot of it. By the time I returned to the house, I wasn't walking very straight and Maw began to inquire where I had been and what I had been doing. It didn't take her long to find out that I had been sampling some blackberry wine that my brothers Johnny and Freeland had made and hidden there. On that occasion, *they* got the rough side of her tongue—not for making it, since boys will be boys, but for leaving it where I could find it.

Another reason I had so few children to play with was that by December 1935, only twenty-one scattered families remained in the Cove. The rest had taken whatever the government paid them for their farms and moved out. There was not even a school close enough for me to attend. Our nearest neighbor, John Tipton, had some children, but I did not consider them suitable company—they were all girls.

The child in the photograph on the next page is Leroy Myers, the son of my cousin Floyd Myers and his wife Leona. I look very pleased to have a visitor about my age, but I doubt that Leroy was able to keep up with my more energetic adventures. I was a big, healthy child, accustomed to running barefoot wherever I chose, but Leroy had severe asthma and was always sickly and small for his age.

Leroy was an only child. He lived with Floyd and Leona on Pea Ridge Road near Maryville, and once I went there to stay overnight. This was a new world to me—they actually had electric light at their house! Being so frail, Leroy was protected and his wants were indulged by his parents. Floyd took us to Jeff Cable's store, where we were spoiled with all the candy and chewing gum we wanted. I couldn't imagine having a place to shop any time you liked—no waiting all week for the rolling store! Poor Leroy contracted spinal meningitis and died while still in his teens.

When I was a very small child, there were still several general stores in the Cove. In fact, my first outing away from home was to W.A. Hill's shop, as recorded in the baby book my mother kept. Mr. Hill's establishment soon closed; as the Park Service began to buy up land and people moved away, the others closed one by one. Walker's Rolling Store became our source for necessities we could not grow or make at home.

I looked forward with great anticipation to Wednesdays, the day the rolling store made its rounds. My mother and I—I called her Maw and so did everyone else, including her grandchildren—would walk down beside the Post Branch to John Tipton's house to meet it. The "store" was essentially a large box built on a truck bed. It had an aisle down the middle and shelves on each side. That old truck *smelled* like a store! Goods were kept in sacks and open boxes, not sealed and shrink-wrapped as they

One of my rare playmates, Leroy Myers (left).

are now. We could buy sewing supplies, tobacco, flour, kerosene, sugar, pens, writing paper and even lard. Most Cove residents raised hogs and rendered their own lard, but families were usually large and would run out of this essential commodity before hog killin' time came round again. To make good biscuits, you had to have hog lard! We bought coffee, another essential, but back then it certainly wasn't instant. Bags of whole beans were weighed out and we ground them at home.

Many Cove wives traded butter, chickens or eggs for goods they needed. There was a barrel beside the entrance to the truck and all the butter was put in it. Butter was brought for trading carefully wrapped in wax paper, but in warmer weather there was no way to keep it cool.

There was a coop for live chickens on top of the truck cab. I had a flock of bantam hens but never traded them. On "rolling store day," I would search the yard for their hidden nests, gather as many of their little eggs as I could find and take them to swap for sticks of hard candy. Maw's

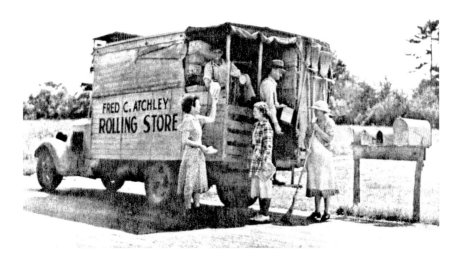

Atchley's rolling store. *Courtesy of the National Park Service Archives.*

favorite was horehound but I liked peppermint best. Being the baby around our house, one of my few chores was feeding a little corn to those "banty" chickens. They didn't need much care. They ran free in the yard during the day, and since they could fly like birds, they roosted in the trees at night to be safe from the foxes. I could find no photo of Mr. Walker's rolling store, but it was very similar to the vehicle shown on this page, which I found in the National Park Service Archives. There seems to be no barrel for butter on Mr. Atchley's truck, but the cage for live chickens is perched on the top at the front, just as I remember.

Once or twice a year we would go to Maryville. To me this was like several Christmases rolled up into one. Since the trip took an entire day, we had dinner family style at Baker's Boarding House on Broadway, where several Baker daughters kept the table supplied with such rare treats as beef stew and iced tea. How I loved that cold tea with real ice chips in it! Beef stew was also almost unknown at our house; on rare occasions, someone would slaughter a cow and come around selling beef from house to house, but most of our meat came from Dad's hunting trips. We had bear, squirrel (with dumplings of course) and often wild turkey. Dad was considered to be an outstanding turkey hunter. The turkey call he used still sits on my mantel. For thirteen years "hand runnin" he said, we had turkey breast with gravy for Easter dinner.

Even so, many of our meals were meatless, consisting of vegetables from our garden, with lots of cornbread. We sometimes had fried chicken

from Maw's flock for Sunday breakfast, though not often because hens were kept mainly for their eggs. The Cove streams were full of trout, so we had plenty of fish. Oddly enough, I never fished much with Dad when I was small (he would usually take one or two of my sisters), but when I was older and living in Maryville I went fishing at every opportunity. I'm not saying I ever got more than my limit, but a certain park ranger was heard to say that his ambition in life was to catch J.C. McCaulley with more rainbow trout than he ought to have. We had some great fish fries. No ranger ever thought to look in my spare tire.

The meatless meals were largely my mother's responsibility because she did most of the gardening, particularly as Dad was often working away from home. Our garden was large. We needed enough vegetables to feed us through the summer and to preserve for the winter. Maw put up a great many cans, and pickled beans and corn in barrels.

The garden was enclosed by a picket fence and another of my few chores was to chase the chickens out when they got inside. My little bantams could fly so well that a picket fence was not much of an obstacle to them so I had to do it quite often!

Dad didn't put a lot of faith in it but Maw planted the garden mostly by "the signs of the moon." This is a complicated system dictating when each type of crop should be planted—the signs must be "in the knees," for instance, to put in all root crops. Many people then consulted an illustrated almanac to see if the signs were favorable for almost any activity—setting fence posts, cutting wood, breeding animals and so on. Maw's parents had probably followed this practice and she continued to do as they did. If the weather was suitable, she liked to have her beans planted by Good Friday, and the corn had to be in by the time white oak leaves were "as big as a squirrel's foot."

One of the few times I can remember being spanked was because of my parents' intention to leave me at home while they went on one of those rare trips to Maryville. I was to be left with my older brothers (Freeland was to take me out to ride my tricycle while they left, but I had already overheard their plan to leave me behind). I took the keys out of the car and hid them. Big mistake. At least my mother gave the spanking, and not Dad. Dad was not a man to be trifled with at any age.

My sister Icyle found this out when she was fifteen or sixteen years old. She had been seeing a young man. Perhaps they had quarreled, but in any case she meant to elope with another boy. She confided the plan to sister Anna Lee, who told Dad about it not long after Icyle left the house. She also knew where he might intercept the pair before they were out of the Cove. Dad put

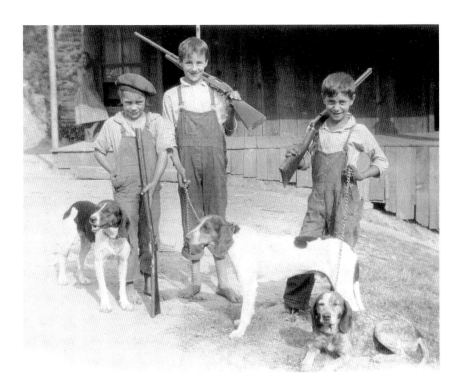

Anna Lee, John Earl and Freeland—ready to go hunting!

A painting by Freeland McCaulley.

a .45-caliber pistol in his pocket, took Johnny (the oldest son still at home) and went after them. Shortly he returned with a very silent daughter and nothing further was heard about any wedding plans. Icyle eventually married Virgil Gregory. At one time, Virgil's father made moonshine whiskey and Virgil was the son who transported it to Maryville or Knoxville in a fast car. He escaped arrest but never became a NASCAR driver like some others whose careers began by "souping up" cars in order to outrun the police. He and Icyle relocated to Michigan where their children still live.

The tricycle I mentioned was one of my few toys. Christmas was not an occasion for giving or receiving presents, nor did I ever believe in Santa Claus. I usually got a little candy and perhaps a few oranges and bananas. Maw would try to make a little more special meal than usual, almost always including my all-time favorite, banana pudding.

There was almost no flat place to ride my tricycle. Freeland usually pushed it, or towed me about at the end of a rope. A much more exciting ride was in the wagon made by Freeland and Johnny. Most boys built these with wheels cut from round logs, but my brothers' design was quite advanced—the wheels came from old steel wheelbarrows. It could be steered, so they would come flying down the steep hill past the house, around the bee shed and end up by the spring. Unfortunately, the time they decided to give me a ride we went well off course, luckily missing the beehives but tumbling in a heap over the rock wall. There were no serious injuries but Maw allowed no more riding in the wagon, at least for me.

Freeland was the brother who bought me toys when he was old enough to get a job and had money to spend. I treasured the "fire chief's car" he got for me. In fact, I was always extremely careful with what few playthings I had and hid them under the bed when children came to visit, in case they should be broken. A fair collection of them was still at Hubbard when I went into the U.S. Army. Maw gave them away to her many grandchildren. Too bad, because those old toys in mint condition now bring high prices from collectors.

The photograph seen on this page, taken shortly before I was born, shows several young McCaulleys posing with guns and dogs—the "boy" at left is actually my sister, Anna Lee, who obviously needed some lessons in gun safety. Next to her is John Earl and at right, Freeland.

Freeland had some talent as an artist. As soon as he could afford to buy the materials, he started making sketches and then painting in oils, usually taking as his subject some scene in the mountains. Painting in oils continued to be his favorite occupation throughout his lifetime.

MAKING A LIVING

The Tennessee Valley Authority began the construction of dams on rivers in several Southern states in the mid-1920s. TVA was part of Franklin Delano Roosevelt's plan to combat the poverty of the area by controlling floods, generating hydroelectricity and making it widely available, thus attracting industry and providing employment.

Dad went to apply for work as a carpenter at the Calderwood Dam. He was one of many applicants, both jobs and money being in short supply in those hard times. He had not thought it necessary to bring tools with him, and the man taking applications was skeptical about his skills. "How are you going to work?" he asked. "Don't you have any tools?" Dad said, "If I have to, I can hammer nails with a rock! I NEED A JOB!" The man thought for a moment and said, "Anybody that determined ought to have one—you're hired."

While Dad worked at Calderwood, he stayed there during the week in the barracks provided for the workers. He cut men's hair to pay for board, lodging and tobacco, and saved all his pay. Before buying his car in 1929, the same year I was born, he would walk home on the weekends to be with the family. This was a hard hike of eight miles through the mountains, and he had to start back right after dinner on Sunday.

About this time there was a man who wandered all over the mountains, living wild in the woods. His name was John Cooper. John probably knew every cave or abandoned house where he could take shelter in the worst weather, but he usually slept out in the open. He would sometimes come around to beg a little food. It must have been a hard existence but it was the life he chose. John could sometimes be a little picky, though. He once came to our house and Maw gave him a sausage biscuit. Watching through the window, she saw him toss away the biscuit and eat the meat as he walked down the hollow.

One winter morning, the workmen at the dam were finishing their coffee around the barracks stove; it was a Saturday, but so bitterly cold that no one was ready to start the weekend trip home. John quietly slipped into the room. He stayed at the far end from the fire, but even so it must have seemed luxuriously warm to him. After a while, one of the men noticed him and said, "How did you make it last night, John? Pretty cold, wasn't it?" John thought for a moment and said, "Well, it would have been if you didn't understand camping." John understood it very well indeed to avoid freezing to death in such weather—his method was to find a large, flat rock, and on it he would build a fire, keeping it burning for a long time. When it died down to ashes, he would sweep them aside and lie down on the warm stone to sleep. To this day, the answer in my family when anyone comments on cold weather is, "Well, it is cold if you don't understand camping!"

Dad sometimes took a wagonload of produce to sell in Knoxville. This took three days—one to get there, sleeping just off the road outside the city, one to sell his goods and one to return home. Sometimes he went to the market, and other times around to residential neighborhoods. He was a great salesman. When a potential customer would tell him she didn't need any corn, for instance, he would stand and chat with her, casually peeling the shucks from a particularly nice ear. She would often go home with a dozen ears of that corn she said she didn't need. He also sold apples, honey and chestnuts in season. He once took some jars of honey to the market, with a label on them bearing his name. A man picked up a jar, read it, and said, "McCaulley is your name? Spelled with two *l*'s?" Dad said that was so. The man said that that was his name also, and he had never before met anyone who spelled it exactly the same way. They discussed why this might be, and the man's story was that he knew of two of his ancestors, brothers, who came to America from Ireland together. Shortly after their arrival, they went their different ways and never met again. We have several family members who spend a lot of time tracing our genealogy but this story has never been heard from anyone else, though McCaulley kin have been identified in several states.

The wagon Dad used to take loads to Knoxville and for other trips was pulled by a team of small, matched mules. The roads outside the mountains were easy going, but some of the slopes those little mules climbed were very steep and with a heavy load they occasionally went to their knees to pull. For these steep areas, the wagon was fitted with a "dead man"—a 4"x4" hewn from a log that was attached under the wagon bed, pointing towards the rear, and at the end of which was an old

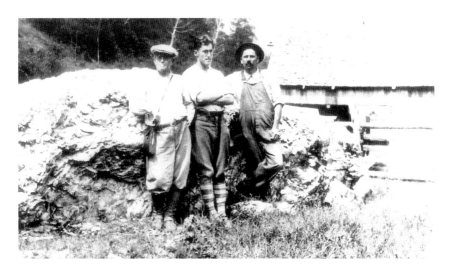

Mr. Reynolds, his travelling companion and Dad, leaning on one of the white rocks; the rocks were my favorite place to play. Our large barn is in the background.

plow point. If the mules lost their footing and the wagon slid back, the plow point would dig into the ground and act as a brake.

The people who came to the Cove for Dad to guide them on hunting or camping trips were many and varied. Some were old family friends who lived in Maryville or elsewhere in Blount County and some were men of considerable wealth—Dad was at ease with anyone, whatever their station in life. One such person was Mr. Reynolds, who had at one time been persuaded by a friend to invest all his savings in some lots in the small town where they lived. Nothing resulted from this investment for a few years, but eventually a railroad or highway was built that caused the town to grow, and when he felt the time was right, Mr. Reynolds sold his properties for enough money to make him very rich, possibly even a millionaire. One day he observed Dad sharpening a large blade, having some difficulty with holding it and at the same time turning the grinding wheel. "Here, John," he said. "Let me give you a hand with that. Goodness knows I never have to do any work any more. I can at least help you a little."

Mr. Reynolds told Dad a story about an Eskimo guide he had employed on a number of hunting trips in northern Canada. Having a high opinion of this man, Mr. Reynolds thought he would like to show him a very different part of the world. So he took him on a visit to New York, thinking how impressed the Eskimo would be with the city. The

trip, however, lasted a very short time—even though they went at a cool time of year, the Eskimo found the heat so overwhelming that he had to return home almost immediately.

I have sometimes wondered how things would have turned out if he had taken Dad on the same trip. It's my opinion Dad wouldn't have stayed long either. The mountains were in his blood, the place where he was happiest. He could have seen all of the city he cared to in a very short time and been ready to go home.

AUNT BECKY CABLE

Most visitors to the Cades Cove of today visit the Becky Cable House, which stands across from the bookstore and is surrounded by barns, a forge, a corncrib and the Cable mill. All except the mill have been moved from their original locations, including the house, which stood where the bridge crosses Mill Creek, a short distance up the gravel road that branches off from the Loop. I can remember when it was located there.

I must explain to those who are not familiar with the old Southern custom that "Aunt" and "Uncle" were terms of respect often used when addressing older people and so Becky was called "Aunt" even by those not related to her. She was a greatly respected member of the community. Most women of the time acquired their status from, and were supported by, their fathers and then by their husbands, but Aunt Becky never married. She ran her farm and other enterprises very capably and needed little help from anyone.

At various times, Aunt Becky kept a store, or boarded and fed summer visitors in addition to farming. She rarely wore shoes, and the story of her encounter with a rattlesnake is well-known. Finding that she had almost stepped on it as she went about her chores, but had escaped being bitten, she decided to return the favor and let the snake live.

Of course, Cove residents did favors for each other, and in return for the many times that my father assisted her with difficult farm chores, or made coffins for family members, she once made him a fine pair of long wool socks to wear under his knee-high boots. She normally charged fifty cents a pair, having raised the sheep, sheared them, spun the wool and knitted the socks!

Aunt Becky took over the care of her brother's children when he was confined to a mental hospital and while his wife was also ill. The family included his son Perry. Perry was what might now be called mentally challenged and had some strange habits. He would stand for hours out

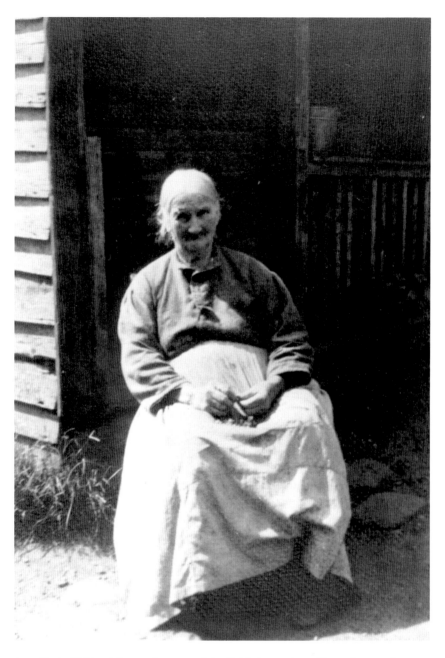

Aunt Becky Cable, sitting on the steps of the Cable house that still stands across from the Cable Mill, Cades Cove.

in front of the house, wearing a dress and swaying from foot to foot. I am sure now that he was quite harmless, but I was afraid of him and would go out of my way to avoid meeting him in the road. He loved Prince Albert tobacco cans and would tear off the lids, carrying them around tucked in his armpit. Once he managed to hide a lid there for so long that the rough edge had caused a terrible infected sore by the time it was discovered.

When Aunt Becky died at the age of ninety-six, we had moved from the Cove but Dad, having made coffins for all his neighbors as long as he lived there, made his last one for her. He had actually started on it some years before, when she became ill, but upon her recovery stored it carefully in our barn on sawhorses until it should be needed. For her he had never done this before—he ordered cloth from a funeral supply house and carefully put in a lining. The costs of the materials for this special coffin are listed in his notebook as follows: handles cost $4; additional lumber $3; padded fabric and lining $4.63. When it was completed, I climbed up into that coffin and lay down in it to see how it fit.

Dad made coffins for as long as he lived in the Cove. He regarded it as his community service. Grandfather James had done it before him, and Dad learned the skill by helping his father. Cove residents usually knew who was seriously sick and if they were likely to survive or not. When a death occurred, a church bell would first be rung to get attention and then tolled once for each year of the deceased person's age, which told everyone who had died. If the wind was in the right direction these bells could be heard at our farm, except the bell at the Primitive Baptist, which was at the far east end of the Cove. If Dad heard one as he went about his chores, he would know that a task would be waiting for him that night.

When a walnut tree was felled, the lumber was sawn into boards and set aside to be used for a coffin when the need arose, so materials would usually be ready for Dad to start work. Walnut was valued as the finest lumber to be had—it grew straight, without knots, and had a beautiful grain. People wanted their beloved family member to be laid away in the best they could provide. A helper sometimes came to our house, or if the family had lumber at their house Dad might take his tools there to make the casket. The job would take a day and most of a night. Dad also helped to prepare the body for burial and transported it to the church on his wagon. For all this he took no money. He was glad to do it for his neighbors and knew that if he ever needed help in return it would be there.

HOME MEDICINE

Most of our minor ailments were "doctored" at home. Like most Cove residents, my parents knew what wild plants had curative powers and where to find them as needed. When I had a high temperature, Maw would brew up "feverweed" tea. This tasted very pleasant. Yellowroot tea, used for sores and ulcers of the mouth, was horribly bitter—a case of the cure being worse than the disease. The treatment for chest congestion was a poultice of peach leaves, or depending on the season, mullein leaves. These smelled very bad indeed. It was almost worth being sick, however, to get some canned grape juice, which Maw used as a reward for taking medicine. The grapes grew on our garden fence and the juice was preserved with plenty of sugar. I was taken to see a doctor on one rare occasion when I was four years old and had a serious ear infection that had to be lanced. Maw took me to Maryville for this procedure, but there was some delay in carrying it out—not used to being handled by strangers I had managed to hide myself under a desk for some time before they found me.

My sister Icyle got some home emergency treatment when she was about four. She had gone with Dad to feed the pigs. When his back was turned, she stuck her finger through the fence too close to the feed trough, and a hog bit it off. Only a shred of skin held it on. Dad rushed her back to the house. Holding the finger in place, he bound it tightly and coated the bandage with melted paraffin wax. For weeks, she would not allow anyone to touch it, let alone remove the wrapping, which got extremely dirty. Eventually, she was persuaded to have it taken off. The finger had healed, leaving only a faint white ring around it. The scar hardly showed, but the finger was always numb.

Dad never did like to go to the doctor. In place of hay, we always cut corn leaves, called fodder, for feeding our cows in the winter, and one day he had made several piles of them to be loaded on a sled and put

in the barn later. The next day, as he picked up a pile, he was bitten by a copperhead hiding beneath it. He went to the nearby stream. After washing the arm, he took out a wad of tobacco he was chewing, bound it on the bite with his handkerchief and just went back to work.

Losing the tips of his fingers was a lot more serious. It happened when we had left the Cove and were living at Hubbard. We were putting hay into the barn, using a hayfork pulley to hoist it to the upper level. This works by having a horse haul on the rope, positioned on the other side of the barn from the pulley. I was working there with the horse, so when Dad gave the "pull" command a second too soon and got his fingers caught in the pulley he was dragged up and suspended in the air for a few moments before I realized what had happened and got the horse stopped. I hastily backed the horse to let him down. Several nails were torn off and the tendons were stretched well beyond the tips of the fingers. It must have been terribly painful, but we went to the house, where he had me cut the tendons off with scissors, then bind up the hand. I was about fourteen years old when this happened and I still remember my horror at the sight of the bleeding fingers and how difficult it was to carry out the snipping and bandaging. Later that evening, Maw insisted that he go to see Doctor Gamble. Doc said, "What are you coming in now for? I can't do any more than you've done already!"

I had had plenty of experience with horses and farm machinery before this incident. Dad would put me out in the fields with a four-horse team at twelve years old. On more than one occasion, I had horses run away with me, breaking down fences and gates, and once a horse fell in the traces, which could have resulted in a broken leg and a dead horse. Fortunately it escaped injury and somehow so did I—pretty soon I learned to leap off when I felt there was no stopping the team. I guess Dad felt that the way to teach me these chores was just to put me to work and leave me to learn the hard way.

In 1919, my mother became sick with tuberculosis, a rare disease now but very common in those days. She was taken to Walland, where she stayed with Dad's sister, Rachel, in order to be closer to medical care. Mayme, twelve years old, took over most of the cooking, cleaning and housework, no small task for such a young girl. Eventually, the doctor said he could do no more for Mother, so she was brought home, having grown so weak and thin Dad could pick her up like a small child and carry her to lie on a blanket before the fire.

This was a desperate time. I have been told that Dad went out into the woods and prayed, begging God to take him instead of his children's mother.

He thought of one more thing he could try. Dad always had many friends on the nearby Cherokee reservation and went there to consult an Indian he knew. He learned about a certain medicine. Its ingredients included various herbs and the bark of several kinds of trees, including chestnut—which was easily found in the mountains before the blight killed all the chestnut trees—and wild honey. It also required apple brandy, another matter entirely since the making of any kind of liquor was illegal unless you held a government permit. Of course, plenty of moonshine was made back in the hills. In fact, a state agent was stationed in the Cove to detect any such activity. Dad knew this man and went to see him. "My wife needs medicine," he said, "and I'm going to make the brandy to put in it. I'll be making it up the hollow behind my house. I advise you not to come up there until I'm finished, or you'll go out feet first." The agent was a sensible man and stayed well away from Dad's activities.

A still was borrowed from a sympathetic friend, set up near a spring and the brandy distilled. Dad's Indian consultant came to help, and when the medicine was concocted, he advised that Mother should take two tablespoons every hour. If there was no improvement in two weeks, when the medicine ran out, he would come back to make more, he said. But in two weeks Mother was slowly making her way to the kitchen to help with the cooking. She recovered and lived into her eighties. Only in the last year or two of her life did her coal black hair show a strand or two of gray.

INDIAN CONNECTIONS

I have said that we had many friends and acquaintances on the Cherokee reservation. One Indian friend of our family was a man named Willie Owl. Dad was on very close terms with him and took me to spend the night at his house on several occasions. Willie was a Baptist preacher and officiated at Dad's funeral. His wife Stella was also a visitor to our house when I was small. I remember her bringing me Indian beads to play with.

Willie's father was named Solomon Owl. He lived in an old house with a big fireplace, beside Goose Creek on the reservation. One very cold night his little daughter awoke crying for a drink, and Solomon got up to bring her some water. Passing through the living room he saw a stranger sitting over the dying fire. The stranger did not speak, and neither did Solomon. Giving his little girl the drink, Solomon said, "You'd better be good and go back to sleep or I'll let this man take you with him." When he came back through the room, the man was gone. I believe it was an Indian custom to permit anyone passing by to take shelter and warm themselves if they needed to—if so, we followed it, because our doors were never locked.

I have among my papers a letter copied from an original in the Lawson-McGhee Library concerning Dad's good relationships with people on the Cherokee reservation. It was written by A.J. "Jack" Fisher, for whom Dad worked as a foreman with the Civilian Conservation Corps. He relates how Dad at one time took two sick Indian men into our house and cared for them until they recovered. On their return to the reservation, they spoke about Dad's help and the matter came to the attention of the chief, who sent a message asking him to come to the reservation, which he did. In recognition of his good deed, he was given the privilege of hunting and fishing on Indian land, the only white man in our area permitted to do so. In past years, others had been allowed to hunt there and abused the favor, shooting only for sport and leaving heaps

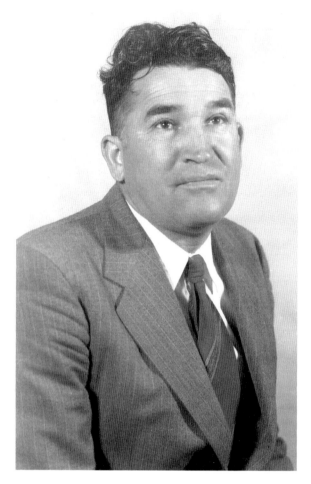

Dad's Cherokee friend, Willie Owl.

of dead game, which the Indians rightly viewed as a terrible waste. When the town of Cherokee was developed into a tourist attraction, Dad was offered the opportunity of opening a business there but he didn't accept. Spending his time in a store would never have appealed to him, and the money he could have made was not important. Living free in his beloved mountains was his life and he lived it until he was forced to leave them.

The letter from the Lawson-McGhee Library reads as follows:

Dear Mr. Overby:

You may have read the enclosed clippings in the Knoxville Journal. Might be of interest to our Historical Society. John McCauley was one

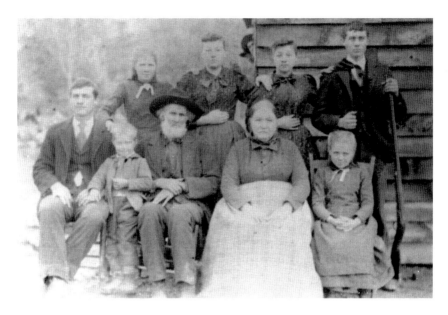

Part of the Myers family. My mother is third from the left on the back row.

of my foremen in CCC camp #11 in Cades Cove. He was 80 years old April 10, 1960 and I was 80 June 26 1960. In one of the articles is mentioned Tom and Jerry Hearon, both now deceased. They were the men who helped us restore the Cable Mill in '37. John McCauley years ago befriended a couple of sick Cherokee Indians in his home in Cades Cove. When they reported their treatment to their Chief on return to the reservation he immediately sent for John to visit him.

His visit resulted in the Chief giving him (the only white man) the privilege of hunting and fishing on the reservation.

I understand this privilege is still effective.

Sincerely, A.J. Fisher

These friendships with Indians may have been because my father always thought he was part Indian himself. No proof of this exists. Late in the nineteenth century, it would be something a person kept quiet about. It is also believed that my mother's mother was at least part Cherokee, so it is likely that I have Indian blood on both sides of my family.

THE WALKER SISTERS

A favorite short hike destination for visitors to the Smokies is the old schoolhouse and the cabin of the Walker sisters in Greenbriar Cove. John Walker and his large family lived there, and for many years after he died, his five unmarried daughters still kept to their simple way of life—farming, gardening and spinning and weaving the cloth for their clothes. Their log house is carefully preserved by the Park Service, but the forest has grown up where they cultivated their gardens, grapevines and apple orchards.

We knew the Walker sisters well. Dad took me there many times to buy apples. Some of the visits we made to their small cabin were in the late 1930s, after we moved from the Cove. We had no apple orchard at Hubbard and would go in the fall to buy fruit. As I recall, all five of the sisters were living then, though to my ten-year-old eyes they were interchangeable old ladies, all in long black dresses.

There was a gate across the road into the property, and much of what is now wooded was open land, with large gardens and "truck patches" behind the cabin. To the left on entering the gate was an orchard, with many apple trees and some old-time cling peaches. This area was fenced, as a few cows and some sheep, kept for their wool, grazed among the trees. The spring house can still be seen. Beside it then was a large grape arbor, and many walnut trees grew around the house.

Looking out from the front porch, there was a smoke house, still standing, and beyond that a fairly large barn. The soil there was fertile but very rocky. Around the edges of the woods I remember large piles of stones, plowed up and removed from the gardens. On the porch stood a spinning wheel and a loom, made by John Walker, as were many of the tools and implements used around the farm. Mr. Walker must have loved the peace and beauty of his home, as he was a survivor of the infamous Civil War prison camp, Andersonville.

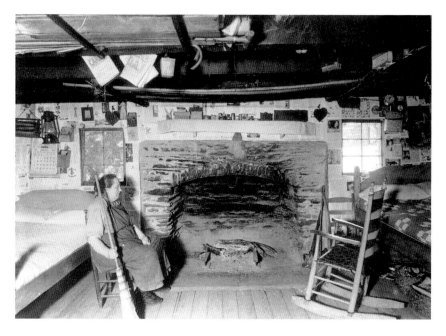

Interior of the Walker sisters' cabin—trundle beds, handmade quilts and a long rifle.

In later years, the sisters were the subject of articles in the *Saturday Evening Post* and other publications, notoriety that brought a stream of tourists to their door, usually people who gave no thought to the fact that making a living off the land took a great deal of time and effort. After a few years, the novelty of constant visitors had worn thin and they began to guard their privacy a little more, asking the Park Service to remove the sign pointing to their farm. When I was about twenty-five and recently married, my nephew Arnold and I took our wives up to their house and I went ahead to knock and see if we would be allowed in. All I had to say was, "Do you remember me? I'm John McCaulley's boy," and the door was thrown open.

Only two of the sisters were still living then and one brother was there visiting. He never said a word the entire time, but the sisters were most hospitable, exchanging recollections of my family and even singing us a shaped note hymn. The walls of their low-ceilinged cabin were papered all over with ancient newsprint to keep out the drafts, and I believe they had saved every calendar, letter, magazine, brochure and newspaper they had ever received because there were stacks of them under the beds and against the walls.

Being a gun fancier, I admired the long rifle hanging on the wall—I believe it is now in the Walker Sisters Collection at Park Service headquarters. Our wives looked in amazement at the fireplace, so large that the sisters used a small mule to drag in the logs for it. The living room had two doors in a direct line so that the mule could enter through one and leave through the other.

The sisters had known nothing but hard work all their lives but they wished for no other way of living. They did not feel deprived because they didn't have the luxuries of the modern world. They could have sold their property to the Park Service like the rest of us who moved to "the outside," where they could have had electricity, running water and many of the other amenities that make life easier, but they valued their mountain home above all else and fought successfully to keep it.

I feel privileged to have known these unique women whose like has vanished from America.

THE QUIET WOMAN

It occurs to me that I have said a great deal about my father and very little about my mother. This is hardly surprising—Dad was such a dominant personality, firm in his opinions, usually following each pronouncement with, "Ain't no question about that," and would talk to anyone about anything. Longtime readers of the *Knoxville News-Sentinel* have probably read many of the columns written about him by the late Vic Weals, who often said that John McCaulley was his favorite interview. As the reader can see by her early photographs, my mother was a beautiful girl, but she was a quiet and unassertive wife. Her home and family were her world, and she wished for no other. My father's word was law. They would occasionally come to visit my wife and me in our Maryville apartment. Maw would sit on the edge of her chair the entire time, and soon ask if Dad wasn't ready to go home and milk the cows yet. At home on the farm was where she felt at ease. Being the child of their old age, I was a favorite and they depended on me—no Sunday could pass without taking our baby son, the third James McCaulley, out to the farm to sit under the maple trees, chatting with visiting family members and friends, and romping with the dogs.

Maw's many grandchildren were devoted to her. They could always come to her for consolation if they were in trouble at home, visit for a few days if they chose or get a little money for candy or tobacco, if she had it. Usually she had none; after selling a few cows, Dad would keep several hundred dollars in his pocket and she would meekly go and ask for two or three dollars to go to the store. I can't remember that she ever exercised her right to vote. She considered that "men's business."

As the youngest child, I probably got less discipline than her other children. Apart from stealing the car key, I can only remember seriously annoying Maw one other time. We had a number of young men in the

My mother, Rutha McCaulley. *Courtesy of Trish McCaulley Abbott.*

Cove in the early thirties who were working for the Civilian Conservation Corps. Two of them were passing by the house one day when I was playing in the yard. They asked if they might get a drink from the spring. Feeling that I ought to offer them something better, I said, "You don't want water! We've got lots of buttermilk, take all you like!" The buttermilk was cooling in the spring and they took such full advantage of my hospitality that when Maw came to get buttermilk to make biscuits there was none. She was definitely upset about that and gave me the rough side of her tongue for being overly hospitable!

Cooking everything from scratch for a husband and large family was almost a full-time job. There were many days or even weeks when Dad was away working and Maw had the responsibility of caring for family and farm alone. She made great quantities of biscuits and gravy and we

always had cornbread with home-churned butter. The leftovers (if any) were tossed out for the dogs. I loved her stack cake, made with apples she had dried in the fall, but my great favorite and a Christmas treat was banana pudding, which of course I called "nanner pudd'n." To this day, I insist on having it for Christmas dinner, though there have been a few additions to Maw's simple recipe.

Improved Banana Pudding

One large pkg. Instant Vanilla Pudding
1 large can evaporated milk
1 can condensed milk
1 small container sour cream
1 large container Cool Whip
Vanilla wafers and (sliced) bananas

Set aside half of the Cool Whip. Blend other ingredients and layer with vanilla wafers. Top with remaining Cool Whip and chill.

Fall is the time for hunting raccoons, and when Dad got a fat young one he would dress it out for a family meal. The 'coon would first be simmered in a huge pot, then the water was poured off and it went into the oven to be baked until tender, surrounded by sweet potatoes. Dad was a master at cooking wild meat, so when game was on the menu Maw stepped aside and he took over the kitchen. Sometimes this was our Thanksgiving dinner.

Occasionally we had 'possum, cooked in much the same manner. One difference in preparing 'possum is that it should be caught alive and penned up for some weeks, being fed clean food. 'Possums will readily eat anything they are given in captivity, but in the wild they have a habit of eating whatever dead animals they come across, so the practice of feeding them for a while makes the meat acceptable and safe for consumption. The woods were full of squirrels so squirrel and dumplings was often on the table also.

I have tasted no bear meat for many years, but I enjoyed it back then. Most people prepare it as a roast or steaks, but Maw would always make a bear stew with vegetables. The meat is somewhat like pork—grainy and rather greasy but with a good flavor. Bear skins, when properly processed, made warm rugs or, in Dad's case, good automobile décor!

Maw's methods of preserving food would horrify nutritionists or canning experts. She never had a pressure cooker, but would put up many

jars of produce from our garden, wild berries, greens, meats and sausage. The meats would have a heavy layer of fat poured over them before being sealed. We also had dried fruit and vegetables, especially beans—the famous "leather britches"—which I never liked but, as Dad put it, they were better than a snowball in the winter time.

Even today many people enjoy gathering and eating wild greens. Ramps, with their pungent flavor, are still popular, and so is "poke salad." Both of them are best early in the spring when they are young and tender. Maw prepared the ramps by "killing"—pouring hot bacon grease over them. The poke salad was boiled, strained, boiled again and then cooked with beaten eggs. Large quantities of it had to be picked, because like most greens a big pot of it cooks down to only a few portions.

THE CIVILIAN
CONSERVATION CORPS

Early in Franklin D. Roosevelt's presidency, he established the Civilian Conservation Corps, an army of young men whose mission would be to repair the ravages of clear-cutting by the lumber companies, and replant the forests. They also built bridges; laid out roads, fire trails and hiking paths; and constructed handsome buildings throughout the National Park System, many of which can still be seen today. Since the date of its inception was 1933 and the Great Depression was well under way, the CCC also provided these youths with training, useful work and a means of earning money, a portion of which was sent home to their families. The men were housed in barracks and lived under a disciplinary system not unlike the U.S. Army, but facilities for recreation and learning were also provided—not a bad deal for unemployed young men, some of whom actually learned to read and write, and acquired skills which enabled them to earn a living for the rest of their working lives.

In the thirties, Dad worked as a foreman for the Civilian Conservation Corps. This was a convenient job, as he didn't have to travel far from home, and it was probably better paid than any he'd had before. He worked for that organization for several years, and was still employed by them when we left the Cove. He helped to construct many of the roads, paths and trails that are in use in the national park today.

Most of the crew assigned to him came from Hackensack, New Jersey, and at first they were raw recruits indeed. Many of them had never been out of the city, so a camp in a remote section of the Smoky Mountains was a new and perhaps intimidating world to them. Dad said that if they got on the wrong side of a tree they were lost. He often came home with an amusing story about these greenhorns. For instance, one of the trails under construction happened to have a large rock projecting out into it from the bank and Dad sent a couple of young men to break it off with a sledge

hammer. After what seemed long enough to complete the job, he went to look for them. They had decided that swinging the sledge hammer was too hard, and were trying to trim off the rock with a wood saw.

I must say that the arrival of several hundred young men to the Cove was not universally popular. The local boys found themselves with a great deal of competition for the attentions of the Cove girls, and occasionally resorted to showering the CCC boys with rocks as they went back to camp after escorting a girl home from some social occasion.

LIFE IN THE LUMBER CAMPS

My sister Mayme was twenty-two years older than I. When I was five or six years old, her husband, Royal Tipton, was working for the Townsend Lumber Company. Before the formation of the national park, lumbering was one of the few opportunities in which to make actual cash income. Not much thought was given to conserving the forest or replanting; lumber companies had free rein to exploit the woodland for maximum profit.

Employees were housed wherever the trees were being cut—Wildcat camp, the Blowdown, Tremont and others. Workers and their families lived in an early version of manufactured housing—tiny units called "car shacks" that were hauled to the camp in sections on the railroad that also carried the logs out. Several units could be put together to make a dormitory, a meeting hall or extra housing for a large family. They were lifted off by a crane mounted on a flatbed, so they had to be set close beside the tracks. People just got used to living in a dwelling that shook when the train went by.

Tremont was a complete company town—a large-enough number of families lived there to need a store, a doctor and a school. There was also a hotel for visiting company executives. Arnold and his older sister Juanita attended school there. I liked to go with Maw to visit Mayme. Arnold and I could play together, swinging on the grapevines in the woods behind the camp.

Juanita remembers that they stayed long enough at each location to raise vegetable gardens. They had no mule so she and Arnold pulled the plow while Mayme held the handles. They also kept hogs, which were partly fed on leftovers from the nearby CCC camp. They must have laid a generous table for those young men because Juanita says that one year they had a hog so large that her father didn't know how he was going to get it out of the pen and to the slaughter site. Mayme solved that

A row of car shacks at one of the lumber camps. *Courtesy of the National Park Service Archives.*

problem—she just filled a pail with slops, showed it to the hog and he willingly followed her to his doom.

Mayme's family eventually numbered eight, three of whom were born in the lumber camps. Like most children in those days, they got few toys and were ingenious at finding things to do. Juanita and Arnold once put a number of corn cobs in the gas tank of their father's car to see what would happen. As the cobs disintegrated, they plugged up the carburetor and it had to be cleaned out many times, a very tiresome job. Juanita says, "Dad got all over us for that," which was probably a mild description.

When it was time to move to a new camp, the little houses were loaded on the train and off they went. The children were allowed to ride in the cab with the engineer, which they thought was very exciting. Juanita was fond of my mother, and came to stay with us for a week every summer until she married.

As the lumber camps were closing down, Dad bought two of the little car shacks and transported them to our farm at Hubbard, where they were used for storage.

WORK, PLAY AND WORSHIP

Most children of Cove families had plenty of chores to occupy their time when not in school. Both boys and girls helped in the fields, putting up hay, cultivating the garden, picking corn, peas or whatever crop was in season. In what free time they had, the boys played baseball (sometimes against teams from the CCC camps). Dad played baseball as a young man. In those days, they had no access to commercially made balls, gloves or other equipment and so made their own. The boys also loved to hunt and fish. Few deer were left in the immediate vicinity—they had been hunted out as the population grew—but there were always rabbits and squirrels, and of course a nighttime 'possum hunt was always popular. Boys would get together, bringing their flashlights or lanterns and their dogs, and stay out as long as they could, keeping in mind that a wake-up call would come early. There were quail also, which were caught by herding them into traps made of vines. Shotgun shells were too expensive to be used on "them little pattridges," as Dad called them. Any game they got would provide a meal. Nothing was wasted.

Sometimes women and girls went hunting too. My sister Mayme could handle a shotgun very well. Late into her eighties, when she was a widow and had no close neighbors, she always kept one loaded behind the door in case of intruders. However, the night she and Maw went 'possum hunting together they didn't stay out long. Many people were certain that there were still panthers—"painters"—in the mountains, and out in the dark woods some noise convinced them that one was close by. They decided to give the 'possums a break and hurried home.

The younger boys usually didn't own foxhounds, but men enjoyed an evening listening to their dogs run. They would gather up on a ridge where the sound would carry well, light a fire and let the dogs loose to find a fox. Then they sat around trading stories and perhaps passing a nip of something to keep out the cold. The dogs would scent a fox and away they would go, the sound of their excited trailing clearly heard for miles. Each man knew

his own dog's voice and could tell how it was running and whether it was in the lead, which was a bragging point. If it got late enough to go home and the dogs had not come back, they were left to run all night and the men would return the next day to collect them.

Girls and their mothers got together for such activities as carding cotton, pea shelling or corn shucking, and of course quilting bees. I can remember my mother making quilts in the evening, but they were not the carefully designed and neatly stitched creations to be seen in quilt shops today. Hers were strictly covers for warmth, made of whatever worn-out clothes or other scraps she had—"mommicked together," in her words. She once gave me enough pieces to make a small one and I would sit beside her by the fire, laboriously sewing it together. I can only imagine what my stitches looked like at five years old.

Teenage boys got up to some pranks on Hallowe'en, which was a popular holiday. Their activities were more tricks than treats. For instance, one year a group quietly took apart a preacher's buggy, carried all the parts up onto his barn roof and reassembled it perched on the ridge. They did come back and take it down in the morning, however. Sometimes the winter would be cold enough for water to freeze in the Pond Woods, the low-lying area just around the Loop Road from the mill. Then the children could go skating, or rather sliding, since none of them had ice skates.

Most people attended one of the three churches—Methodist, Primitive Baptist and Missionary Baptist. Each one had Sunday school classes for all ages and "preaching" on Sundays, occasionally by circuit-riding preachers. Cove churches sometimes had regular pastors, but they needed other occupations also, as they only received what small sums were collected in the offering plate. There were prayer meetings during the week and annual revivals. The Primitive Baptists had foot washings, but our church, the Missionary Baptist, did not, so I never attended one until after we left the Cove.

It was the custom on Sunday mornings to arrive a little early, congregating outside the church to exchange greetings, news and gossip. When it was time to enter for the service, the bell would be rung. One morning at our church, as people were engaged in friendly conversation, the person ringing the bell did so with such energy that the bell broke loose and crashed to the ground, scattering the crowd. Fortunately, no one was hurt.

One of the most important events of the church year was Decoration Day. This was, and is, held on the last Sunday in May, and for weeks beforehand women were busy making crepe paper flowers and wreaths. The graves were mown and tidied in advance. On the big day, there would be preaching, people giving testimony about their religious experiences and singing programs. The children played games and ran all over the church grounds, then at noon

1901 Singing School at the Primitive Baptist Church. My parents are numbered 2 and 3, in the front row.

My grandmother "Sis" Myers; my mother; sister-in-law Dulcie Abbott McCaulley; me; and my nieces Inez and Maycle, daughters of Dulcie and my brother Millard.

the tables were laid for a big feast. I looked forward to this all year—women brought their best and most delicious dishes and I did them full justice! The date would be a little early for garden produce, but everyone had fruit and vegetables canned from last season, and there would be plenty of fried chicken, ham, gravy and biscuits, cakes and best of all to me—banana pudding. In the afternoon, everyone decorated their family graves with the paper flowers. Then there would be more music and "visiting." These occasions probably gave rise to the expression "all day singing and dinner on the ground" in earlier days, though we always had tables for those wonderful meals. People who had married, moved away or changed churches for some reason often came from long distances for Decoration Day at the church they had attended while growing up. They wanted to make sure that the graves of their parents or grandparents were properly cared for, and they looked forward to reunions with friends and family.

Churches were a great source of aid and support for those who were sick, had a death in the family or were in any other kind of trouble. The word was passed on Sunday that someone needed help, and it would soon arrive, whether that person was a church member or not. Food would be brought, farm chores would be done and children would be cared for. Help from family members was usually available, but church congregations did a wonderful job at these times simply because of their numbers and efficient organization.

Sometimes one of the schools put on a play, performed by the students. They also had spelling bees and debates, which were popular and well attended. Young adults enjoyed the singing schools held at church once a year, where they learned shaped note or "harp" singing. The photograph on the previous page shows the school held at the Primitive Baptist church in 1901, with my parents sitting on the front row. They were probably engaged at the time, since they were married the following year.

We often visited Maw's parents, "Cassie" and Mary Ann Myers, and her sister Mary Wright. Aunt Mary's son Charles was about the same age as my brother Freeland and they were great friends. Once Freeland went there to spend the night, planning to bring Charles home with him the next day. Aunt Mary had baked a coconut cake for Mother and packed it up for the boys to carry to our house. It was a fair distance, and the farther they walked the better the cake looked. They broke a bite or two off one corner. Then another, and another. By the time our house was in sight, there wasn't much left. They decided to throw away the remaining crumbs and say nothing about it. Some time later, Aunt Mary visited Maw and asked how she liked the cake.

Maw said, "What cake?" Freeland and Charles made themselves scarce for a while.

COVE CHARACTERS

A man named George Potter was one of our neighbors and he was known to have a passion for collecting the bells that were put on cattle and hogs when they were turned out into the woods in the fall to feed on acorns and chestnuts. Many people made their own bells, and each one had an individual sound which made it easy to locate a particular animal. They could sometimes be found in the woods, but if George fancied a particular bell and couldn't add it to his collection any other way, it was said that he wasn't above shooting the beast to get it.

Of course he didn't get them all—I inherited two my grandfather made. They have a thin coating of brass on the outside, which was done to give them a mellow tone. For many years, we kept one hanging on the porch of our Georgia mountain cabin, where my wife rang it to summon me in from the garden at lunchtime. Now I am passing them on to my sons, James and Steven.

The Garland family was well-known in the Cove. Although an average-sized man, Charlie Garland was famous for his feats of strength, like the time that he allegedly carried an iron stove from Maryville to his house on the headwaters of Hesse's Creek. I have heard that the owner of the store where he purchased the stove promised that it would be free if he could perform this feat, and sent a store clerk along as a witness. This was a journey of about twenty-five miles—Charlie said later that he did put it down once, just long enough to move it to his other shoulder.

Charlie had a son named Jake, also very strong and bigger than his father. As many sons do, Jake got to the age where he thought he could outdo Daddy, boasting that he could "wrassle" him and win. Charlie put up with this until his patience ran out, whereupon he seized Jake by the scruff of his neck and the seat of his pants, lifted him to the ceiling and

A bell made by my grandfather James. *Courtesy of In Focus Photography Lab, 2008.*

banged him against it a few times, then stepped back and let him fall to the floor, almost stunning him.

When telling about this later, Jake commented, "After that I never fooled with Pap no more."

Jake remained a friend of my family long after we left the Cove. Every time we went to visit him at his home near Townsend, he would give Dad a small present. One of these gifts was a quart of moonshine whiskey in the traditional fruit jar. Dad may have sipped (and made) a little in his youth, but having given it up many years ago, he thanked Jake and later buried the jar in his garden. After his death, when I was the administrator of his will and arranging the sale of the farm, I remembered him telling me where it was. I located it, dug it up and took it home. At that time, I lived in Florida and was having a new house built by the Finchum Brothers, Raymond and Clifford. Raymond ran the business end and Clifford was in charge of construction. Clifford liked a drink now and again, and when he heard I had brought back some Tennessee 'shine, he asked me to bring him a sample. I did—a fairly generous one. Next day I went into the office and Raymond yelled at me, "Dammit! What did you do to Clifford?" Apparently Clifford had freely sampled the whiskey and then went out to work on my house, where he sawed off several of his fingers.

Another time Dad and I visited Jake and he presented us with some of his homemade "cough syrup," made from Welch's grape juice, rock candy and whiskey, which probably accounted for most of the mixture. A friend of mine was building a restaurant and I was helping with the electric wiring. Hearing that I had a jar of this concoction under my car seat, my friend slipped out to try some. After he had made several visits to my car, his wife gave him the job of nailing up some curtain rods, but by this time his hand-eye coordination was badly impaired and he hammered a number of large holes into the sheetrock.

When hostilities began between husband and wife, I thought it was time to go home and come back to work on the wiring another day.

Many tales circulated in the Cove about its more colorful characters—stories were relished as entertainment and probably got embellished with every telling. I heard more than once about Will Oliver and his car. Driving over the steep Rich Mountain Road one day, the car stopped and nothing Will could do would get it started. Will was a preacher but had a hot temper and lost more of it as time went by and everything he tried failed. Finally he turned to a fence nearby, tore up a post and beat the car so hard and long that the hood was driven down into the engine. It never ran again.

In an isolated community such as the Cove, people take great interest in their neighbors. Particularly on Sunday afternoons, it was the custom to sit out on the front porch or under a shady tree, resting from the week's work. Many times visitors would drop in, get a cold drink from the spring and sit for an hour's conversation. Babies would be admired, new rifles tried out and the latest news and doings of the community exchanged.

Anyone with some peculiarity or characteristic would soon earn a nickname. Barefoot Jerry Effler's is self-explanatory—Jerry did not wear shoes except in the coldest weather. Although he never lived in the Cove, he was well-known there. He kept a small store in the tiny community of Sunshine, and Cove residents would stop by as they made trips to Maryville or Townsend. Between customers, Jerry would sit out on the porch, bare feet propped on the railing, waving to anyone passing by and perhaps playing his fiddle.

When Jerry was a young man, he became acquainted with Della Ledbetter of the White Oak Flats, and decided he would propose to her. Della listened but either wasn't ready to answer or was playing hard to get, because she replied that she would have to think it over for a few days. Some time later they met again, and having made up her mind Della announced that she was now ready to answer his question. Jerry looked at her blankly and said, "Uh…what question was that?" He must have been joking, however, because they did marry soon afterwards.

Before I was old enough to remember him as a neighbor, George Myers of the Chestnut Flats was a friend of my parents. In his youth, cars were not yet common in the Cove. People either traveled on foot or rode a mule or a horse. George had a small mare and rode the poor animal everywhere at such breakneck speed that he was universally known as "Much Horse." I often heard my mother comment on this habit. When George left the Cove, he lived in the town of Vestal in Knox County and became a master mechanic, having learned this skill entirely on his own. He then owned a car but presumably still kept his love of traveling as fast as possible. I do remember visiting him there with my parents, and on that occasion he took us for quite a wild ride on Fort Loudon Lake in his speedboat. For many years, he continued to visit us at Christmas, always bringing Dad two of the biggest apples to be found in the Knoxville market.

HERDING, HUNTING
AND HORSES

Many of Dad's stories and recollections of Cove life are recorded on tape. He tells of herding cows on the high pastures called balds—"We were 'stationaried' there for the summer," he says. The origin of these balds is a subject for speculation. They are certainly below the timberline but somehow they remain clear of trees. They made excellent pasture for cattle and horses. Every year, large numbers of animals were driven there and turned loose to graze and browse in the woods. Some men took their own cattle but some herded for other owners, who sent their stock from as far as Maryville or even further south.

Herders stayed there to watch over them, living in tiny rough shelters for weeks at a time. They were usually paid seventy-five cents per head to care for the beasts, guarding them from predators and keeping salt out in logs with depressions carved out to hold it—these were called "lick logs." If the herders bought the salt and carried it to the bald, they might receive one dollar per head.

These were beef cattle, raised for sale, but every Cove family also kept at least one cow for milking. A good milk cow was highly prized but, for some reason, cows without horns (called "muleys") were generally thought to be inferior. Dad didn't share this view. On my tape, he tells about buying a muley cow in "North Ca'liner," leading her all the way home, and describes her as "the best cow I ever set a bucket under."

Very few people knew the mountains better than my father. He could stand at Dalton Gap and name every peak and ridge he could see, having tramped and hunted over them all his life. One spring day he was turkey hunting alone on Hannah Mountain and a great storm blew up. Finding a hollow tree, he squeezed inside and sat down to wait it out. When the storm passed and it was time to start home, he found himself wedged and unable to move. He thought about the fact that no one knew exactly

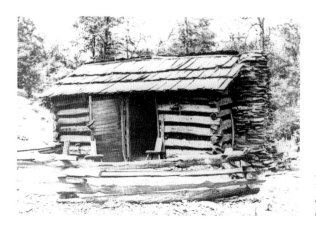

A herder's cabin from the 1890s. *Courtesy of a donation to the NPS Archives by A.J. Fisher.*

where he was, and if he couldn't get free his family might never know what had happened to him—his bones could be found years later, or not at all. Trying to relax and consider what to do, he realized that in his struggle to get out, he had become sweaty and swollen, and that he should rest, cool down and calm himself as much as possible before trying again. This worked and he arrived home with his turkeys, no worse for wear.

Among Dad's other enterprises, he sometimes raised and sold hunting dogs, most of them a Plott/Airedale cross. He also had a dog named Joe, good for hunting bears but he didn't get along too well with humans. If you met Joe in the road, it was advisable to keep to your side and not cross over to his. Dad once went to feed him, and two of the little hunting dog pups ran along. They tried to get into Joe's feeding bowl and he killed both of them before Dad could stop him.

Joe was sometimes allowed to run loose, and one day he disappeared. Dad got a tip that he had been seen, strangely enough, at the farmhouse at Hubbard that would later be our home. He went to investigate and found no one there. The dog was chained under the house and, hearing Dad's voice, came out. Dad just unchained him, took him back to the Cove and nothing more was heard about the theft—Dad always said he couldn't understand how anyone else managed to get hold of the dog and tie him up.

Joe was renowned as a brave bear dog (which probably accounted for his disappearance). He once got a very bad injury. Far back in the mountains, Dad and John Tipton were hunting bears. The dogs had scented one and trailed it until they cornered it, either at the base of a tree or possibly backed up in a patch of Drooping Leucothoe. This plant is known as doghobble because it grows in such thick, huge masses that it is almost impassable to most animals, but bears with their great strength

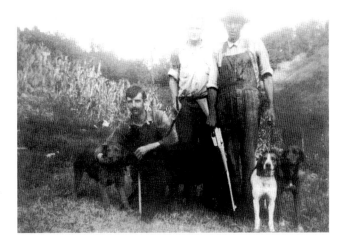

The bear hunters are John Tipton, Charlie Cable and Dad, holding Joe on a very stout chain.

Dad with his rifle and dogs.

would often back up into it when hunted, knowing that the dogs could not attack them from the sides or back. This bear put up a great fight and Joe sustained terrible wounds—many of his hip and spinal bones were completely crushed. Dad carried him all the way home and treated him devotedly. He recovered but was never quite the same.

Shortly before we left the Cove, Dad bought two horses from Becky Cable. One was a black mare that he soon sold, and to replace it he bought a gray horse called Henry. Dad's spelling was not the best but he kept meticulous records of his farm transactions. His note about Henry says that he was bought in Maryville and "mooved" to the farm in March, 1938, the "hall bill" being seven dollars. Henry was a good horse, but some time later unfortunately kicked Dad and broke two ribs. Dad

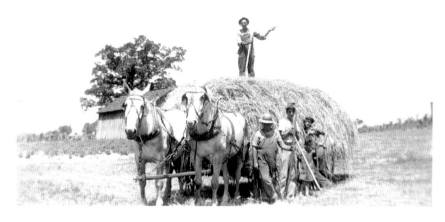

Making hay—the horses are Maud and Henry, Dad stands on the load. Beside the load are me, brother Freeland, neighbor Marion Everett and nephew Joe Gregory.

didn't hold it against him—Henry was actually kicking at the shepherd dog nipping at his heels.

I liked to ride Henry because he was lively and a "fast stepper." Sometimes he was a little too fast—once I was riding him on an old saddle with a makeshift girth that didn't hold together too well and I fell off. He was also clever enough to learn how to open gates and get into the corncrib. His way of moving along pretty smartly made him a bit hard to rein in, especially when plowing between vegetable rows. The only time I ever saw my mother lose her temper with Dad was one day when he was working the garden with Henry, trying to hold him back and Henry was going too fast, stepping in the rows on the plants. Dad laid into Henry with a stick and Maw came flying out of the house and gave him a real dressing down. I guess she had a soft spot for old Henry, too. We got another gray horse called Maud and worked them as a team for chores like making hay, even after we got a tractor.

By 1958, Henry was getting old, and Dad sold him. By then, I was married to my English wife and she was saving up for her first trip back home. As with most newly married couples, we had little money and the saving was going very slowly, so Dad gave her half the eighty dollars he got for the old horse. He was very mindful of the fact that my wife had left her home and family and traveled many miles to marry me, so he took me aside after our wedding and gave me a warning—if I didn't "treat that little girl right," he said, I would be dealing with him. As I mentioned before, Dad was not a man to be trifled with and as always, I have tried to keep his words in mind.

THE CHESTNUT FLATS

Across the hill from the Cove house was a community called the Chestnut Flats, which lay along what is now known as Parson's Branch Road. Most of my brothers and sisters went to school there. Laurel Branch School was within walking distance of our house.

The photograph on the following page shows them about to leave home one morning. Mayme is carrying all their school books and Vicie has the basket with lunch for everyone, which probably consisted of cornbread, biscuits left over from breakfast or cold sweet potatoes.

Clearly there was no dress code in those days. Mayme and Vicie are wearing neat dresses, but Freeland and Johnny have on overalls with rolled legs—and all of them are barefoot.

The Flats people in general were not always well thought of by the rest of the Cove but Dad had many friends there. My parents, although totally respectable and faithful churchgoers, were not judgmental. George Powell, a well-known moonshiner and often in trouble with the law, was Dad's close friend until George's death in 1923. Lyddie Burchfield, whose many children never knew their various fathers, often walked back with Maw and me after our trips to shop at the rolling store.

Old George Powell cultivated large peach and apple orchards in the Flats, distilling liquor from the fruit under a Tennessee permit. He was accustomed to conducting this business on a large scale and so kept right on making his excellent whiskeys and brandies when Tennessee went dry and outlawed making whiskey in 1878—he just moved his operations out into the woods. Naturally this brought him to the attention of the "revenuers," but if anyone gave information to the authorities about the location of George's stills, I'm sure it wasn't Dad. He probably drank a little moonshine when he was young, playing his banjo at dances and play parties, but all that ended when he married and became a church

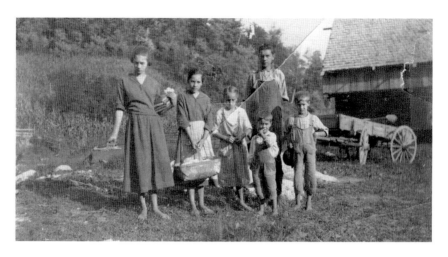

My brothers and sisters just off to school: Mayme, Vicie, Icyle and Millard. In the front are Freeland and Johnny.

Dad's friend, George Powell, at his home in the Chestnut Flats. *Courtesy of Edward Myers.*

One of George's handmade ladles. *Courtesy of In Focus Photography Lab, 2008.*

member. His musical talent was then employed in singing bass in the church choir.

Some of the wagonloads of apples Dad took to sell in Knoxville came from the Chestnut Flats orchards that belonged to George Powell.

George's photograph hangs on a wall in my house and beside it is a ladle that he carved and gave Dad many years ago. George must have made quite a number of those ladles, all of the same design. In his book *Cades Cove and the Chestnut Flats*, Edward Myers, one of George's

descendants, describes his method—finding suitable laurel roots, soaking them in a creek for months and finally carving the ladle. Obviously this took a great deal of patience and time, but George gave many of them away or sold them for fifty cents each.

A recent drive through Parson's Branch Road, which used to be called the Chestnut Flats, reminded me of the many times I went fishing there and of one expedition in particular. Since it was almost in the backyard of my childhood home, I knew the area very well indeed. In the early fifties, when I was married but had no family as yet, my nephew and friend Arnold Tipton and I had our wives drop us off at the entrance to the road. They were to pick us up the next day. As we walked down the road, I noticed that old George Powell's house was still standing.

Arnold and I hiked several miles down the road, getting soaked to the skin by a sudden thunderstorm as we went. Finding some very good fishing holes in Panther Creek, we didn't worry about our wet clothes, but immediately baited our hooks and began to cast into the pools. Only after we had caught enough trout for a good meal did we light a fire and strip, hanging our clothes on sticks and bushes to dry. We had brought a pan and lard to fry our fish and cornbread and a pot to boil water for our coffee. After our meal, we found a level place to sleep, and I selected a smooth rock for a pillow. I was sleeping soundly when something furry, wet and cold plopped onto my face! Reacting quickly, I grabbed the creature and threw it away into the bushes, realizing by its squeals that it was a rabbit. I guessed that it had been escaping from a fox, and had run through the creek on its way to landing on my face. It gave me quite a fright, but worn out with our hiking and fishing, I went back to sleep for the rest of the night.

SECRETS AND STORIES

Possibly due to my father's presence and involvement at the end of so many people's lives—preparing bodies for burial, building caskets, conveying them to their last resting place—he was the guardian of some secrets. People tended to tell him what was on their minds as they contemplated eternity, especially in a day when everyone believed firmly that they would be called to account for their deeds, good and bad.

Although Dad looked back upon his life in the Cove as a golden time, and most of the people he knew as kind and good, in reality this was not always the case. The Cove was like any other community, with its good and bad, its instances of great generosity but occasional evil. Shootings or stabbings were far from rare. Particularly during the time when a number of residents were making illegal whiskey as their main source of income, feuds and quarrels arose over territory, information was given to the police about hidden stills, etc.

And, as in any other time, there were children whose exact paternity was in doubt.

Even such an open and social man had to keep to himself those things that were told to him in the nature of a confession or as a way of easing a guilty conscience. Nevertheless, he shared some of these stories with me during the hours we spent at farm chores together.

One such story involved the well-known and documented case of the shooting of "Little George" Powell, the nephew of old George Powell—Little George probably acquired the nickname to distinguish him from his uncle, since they both lived in the Chestnut Flats.

In 1897, Little George was shot and killed, possibly in revenge for having given evidence in a case against illegal whiskey makers. A man called Hale Hughes was arrested, tried for the crime and sent to prison, although he was not the actual shooter. He had, however, been involved in the plot to kill

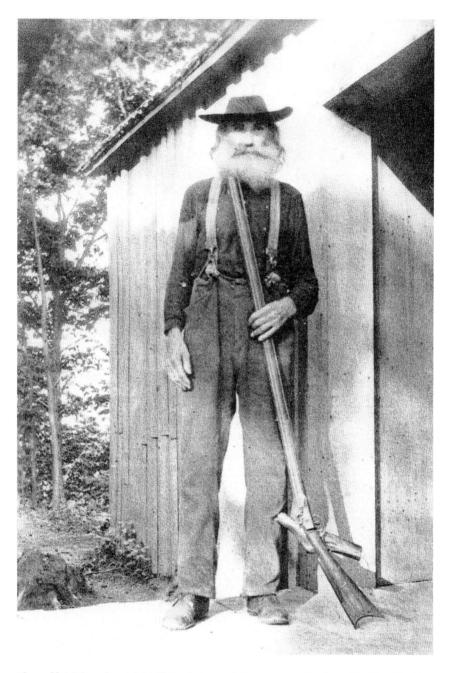

"Long Hair" Sam Burchfield. This photograph first appeared in *Lure of the Great Smokies* by Robert Mason. *Courtesy of Anne Mason Winsauer.*

Little George, together with "Long Hair Sam" Burchfield, his father-in-law. Two years later, Sam was also arrested and tried, but I am not aware of any record of the outcome, and apparently he did not serve any prison time because he returned to the Flats and lived there many more years. This was another case of my father being friendly with a neighbor who had trouble obeying the law. On at least one occasion, Dad tried to get Sam to see the error of his ways, particularly as he approached the end of his life. "Ain't you ready to confess your sins and get saved?" Dad asked, but Sam replied that before he died there were one or two more enemies on his list that he would shoot if he got the opportunity.

The shooting of Little George was reported in numerous newspaper articles and books, but there is an ending to the story that I believe Dad told only to me.

One day in 1917, years before I was born, a man came to our house with a message from Sam. Knowing that he had not long to live, he wanted Dad to come and see him. Dad told me about this on several occasions—"I didn't want to go," he said, "because I knew what he wanted to tell me about. But he was my neighbor. I couldn't refuse." Dad threw an empty feed sack across his mule and rode it across the hill and down into the Chestnut Flats to his friend's house.

On his arrival, Sam insisted that everyone else leave the room. "John," he said, "I have got to tell somebody about this." Sam related how, on the day of the shooting twenty years ago, he had waited in the woods across the branch from Little George's house. From this position, he could see Little George standing in the yard, shelling corn and giving it to his young children to feed the chickens. Sam, hidden behind a large hemlock on a hill above the house, shot Little George in full view of his wife and children. The account of the shooting in the *Maryville Times* describes the plight of George's wife and how George managed to reach the house but collapsed and died in the doorway, trying to reach his gun. There was no one near enough to help her, and, fearing the shooter was still close by, she did not venture outside. She could not move the body, so it lay there all night. It was not until next day that a passerby came to give her assistance.

"I don't regret shooting George," Sam told Dad. "That don't bother me none. But now I can't sleep at night because I hear Martha screaming and those little children crying for their father."

Long Hair Sam Burchfield died the next day, aged seventy-seven.

RETURN TO BLOUNT COUNTY

After many years away from East Tennessee, I have come back to spend the rest of my life in Blount County and sometimes I visit the "McCaulley place" again. It isn't an easy walk. The road once wide enough for my father to drive his '29 Chevy on is rutted and narrow, and many fallen trees block the way home.

The house was torn down by the Park Service and it is hard to find traces of human habitation. Rough stone walls still line the road up the

At seventy-nine years old, I still often visit my childhood home, 2007. *Courtesy of Margaret Osborne McCaulley.*

steep slope to where the house once stood, and hold the bank behind Dad's vanished beehives. My beloved white rocks are covered with moss and rotted leaves, and no longer seem as big as mountains.

No apple trees grow here now, no corn or beans. No cow lows to be milked, no children's voices ring across the yard. Where once Dad plowed his fields and Maw called us in to supper, there is only the sound of the wind in the trees and the flight of a bird across the hollow.

Those white rocks—were they always so small? The creek where a chubby barefoot boy fished with a bent pin still runs clear, but seventy-year-old poplars grow in the fields and the garden spot has been rooted up by the wild boar. There is only a silent clearing here now, this place where my parents worked so hard to raise a family. In a few more years, there will be no trace of us left—no one to find a log or a broken dish and say, "This was my home."

ABOUT THE AUTHOR

I was born in a part of England called the Royal Forest of Dean. It is separated from Wales by the River Wye, and from Southern England by the River Severn. It has an ancient history, with many ruins remaining from the days two thousand years ago when Britain was part of the Roman Empire. Being remote and inaccessible in times past, we Foresters were regarded by more sophisticated folks as being crude and backward—coal miners, charcoal burners and sheep badgers, who spoke in a strange dialect.

This attitude changed with better roads and communications, but until comparatively recent times Foresters still regarded themselves as a breed apart.

I met my future husband on a blind date. One year later, I boarded the *Queen Mary* and sailed off toward a new land and a new life. My mother's family, the optimists and cheerful souls, said, "What a great adventure!"

My father's family, a dour and pessimistic lot, said, "You'll soon be home. Suppose he's changed his mind when you get there?"

But I had the boundless confidence of a twenty-two-year-old, and knew everything would be all right. It has indeed been better than all right, and after fifty-four years, I think I'm here to stay.

Visit us at
www.historypress.net